COOL SHOPS
MILAN

teNeues

Imprint

Editor: Caroline Klein

Editorial coordination: Sabina Marreiros

Photos (location): Gabriele Basilico (Fausto Santini), Fabrizio Bergamo (B&B Italia Store), Andreas Burz (10 Corso Como, Acqua di Parma, Anna Molinari – Blumarine, Boffi, Clone, Costume National, Culti, Da Driade, Da Padova, Dovetusai, Galleria Nilufar, Habits Culti, Il Salumaio, I Pinco Pallino, Lollipops, Roberta Balsamo, Spazio 900), Santi Caleca (Moschino), Courtesy Armani (Spazio Armani), Courtesy B&B (B&B Italia Store), Courtesy Edra (Edra), Courtesy Ergo (Spazio Bisazza), Courtesy Fausto Santini (Fausto Santini), Courtesy Gabellini Associates (Spazio Armani), Courtesy Gucci (Gucci), Courtesy Lolli e Memmoli (Lolli e Memmoli), Courtesy Marni (Marni), Courtesy Pianegonda (Pianegonda), Courtesy Prada (Miu Miu), Courtesy Prada (Prada Donna), Courtesy Claudio Silvestrin (Giorgio Armani Milano), Courtesy Paul Smith (Paul Smith), Ramak Fazel (Moschino Cheap&Chic), Andrea Martiradonna (Dolce & Gabbana), Matteo Piazza (Princi Bakery)

Introduction: Caroline Klein

Layout: Thomas Hausberg

Imaging & Pre-press: Jan Hausberg

Map: go4media. – Verlagsbüro, Stuttgart

Translations: SAW Communications, Dr. Sabine A. Werner, Mainz
Dr. Suzanne Kirkbright (English), Dominique Le Pluart (French)
Gemma Correa-Buján (Spanish), Elena Nobilini (Italian)

Produced by fusion publishing GmbH Stuttgart / Los Angeles
www.fusion-publishing.com

Published by teNeues Publishing Group

teNeues Publishing Company
16 West 22nd Street, New York, NY 10010, USA
Tel.: 001-212-627-9090, Fax: 001-212-627-9511

teNeues Book Division
Kaistraße 18, 40221 Düsseldorf, Germany
Tel.: 0049-(0)211-994597-0, Fax: 0049-(0)211-994597-40

teNeues Publishing UK Ltd.
P.O. Box 402, West Byfleet, KT14 7ZF, Great Britain
Tel.: 0044-1932-403509, Fax: 0044-1932-403514

teNeues France S.A.R.L.
4, rue de Valence, 75005 Paris, France
Tel.: 0033-1-55766205, Fax: 0033-1-55766419

teNeues Iberica S.L.
Pso. Juan de la Encina 2–48, Urb. Club de Campo
28700 S.S.R.R. Madrid, Spain
Tel./Fax: 0034-91-65 95 876

www.teneues.com

ISBN-10: 3-8327-9022-5

ISBN-13: 978-3-8327-9022-6

Bibliographic information published by Die Deutsche Bibliothek.
Die Deutsche Bibliothek lists this publication in the Deutsche Nationalbibliografie; detailed bibliographic data is available in the Internet at http://dnb.ddb.de.

Contents Page

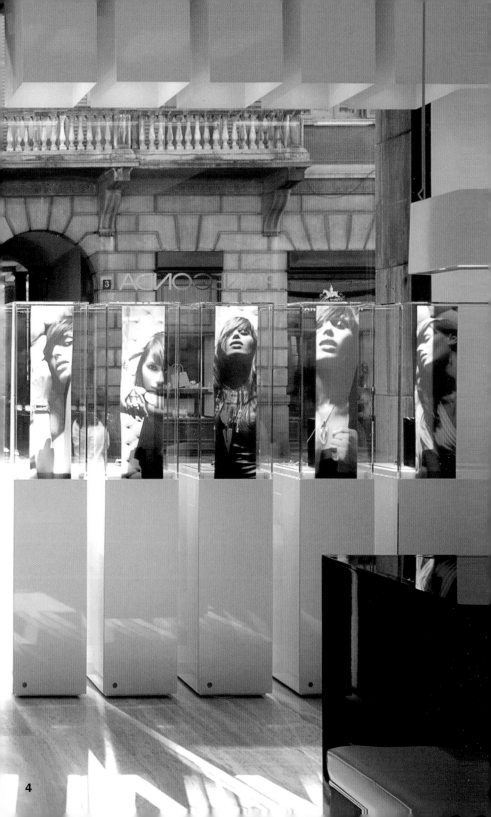

4

Introduzione

Milano, la metropoli della finanza e della moda, si distingue per uno stile di vita tra arte e commercio. Milano è una città vetrina; in ogni suo angolo si è inseguiti dal sogno del lusso. I negozi soddisfano proprio ogni desiderio! Il cuore della moda e del design è soprattutto il Quadrilatero d'oro, tra Via Montenapoleone, Via della Spiga, Corso Venezia e Via Sant'Andrea. In questo luogo magico e allo stesso tempo più che reale una vanità supera l'altra, i negozi lussuosi pullulano vicini vicini, i loro arredamenti e le decorazioni delle loro vetrine si uniscono come a creare una galleria d'arte. Aziende di fama mondiale quali Armani, Gucci o B&B Italia affidano l'allestimento dei propri negozi ad icone del design rinomate a livello internazionale, che, attraverso l'architettura e il design, sanno tradurre con fantasia le idee imprenditoriali e dei marchi e presentare i prodotti alla perfezione. Grazie al loro design insolito, anche negozi sconosciuti, come Spazio 900, Dovetusai o I Pinco Pallino, fungono da "logo tridimensionali". Il settore dello *shop design*, ovvero dell'arredamento per negozi, è soggetto a continui processi innovativi. Negli ultimi anni il commercio è cambiato e con esso il consumatore, che, esigente e troppo abituato al consumo, è ora alla ricerca di valori addizionali e nuove sensazioni. Con l'offerta eccessiva in crescita diventa sempre più importante infondere un plusvalore alla moda. Abbigliamento e oggetti devono essere messi in scena, l'acquisto in un ambiente estetico deve trasformarsi in un'esperienza sensoriale. Il tipo di presentazione allontana i prodotti dalla sfera del puro valore intrinseco a favore dell'individualità. Con 35 boutique *Cool Shops Milan* propone una molteplicità di stili. Il minimalismo rigoroso degli anni addietro viene ora sorpassato da una tendenza che esalta l'idea del lusso e della raffinatezza preziosa.

Caroline Klein

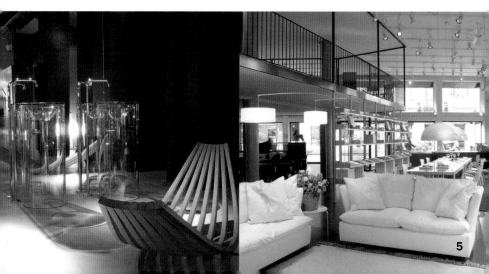

Introduction

The North Italian financial and fashion metropolis is distinguished by a lifestyle shared between art and commerce. Milan is a city of display windows, where you meet the dream of luxury at every turn. The stores certainly fulfil you every wish! The world of fashion and design is primarily celebrated in the noble Quadrilatero district, the "golden square" between the Via Montenapoleone, Via della Spiga, Corso Venezia and Via Sant'Andrea. In this magical place, one vanity out-performs another. At the same time, it's incredibly real and luxurious shops line up right next to each other, with their interior architecture and showcase decoration adding up to create a gallery-style promenade. Internationally famous companies like Armani, Gucci or B&B Italia commission interiors for their stores from world-class design icons, who know how to turn brand and corporate ideas into imaginative architecture and design, as well as to create the perfect staging for products. But thanks to their extraordinary design, lesser known shops like Spazio 900, Dovetusai or I Pinco Pallino also function as "spatial logos". The area of shop design is constantly subjected to processes of renewal. The trade has changed over the past few years—and with it, the consumer, who has high standards and is spoilt for choice when searching for added values and experiences. The growing surplus supply of products makes the inclusion of that added-extra value increasingly important in fashion. Clothes and items have to be celebrated and shopping must become a sensual experience in an aesthetic ambiance. The style of presentation lifts the products out of the zone of pure functionality and symbolizes individuality. With profiles of 35 shops, *Cool Shops Milan* records a wide variety of styles. The strict minimalism of recent years has been pushed aside by a trend, which ranks the idea of luxury and priceless refinement at the top.

Caroline Klein

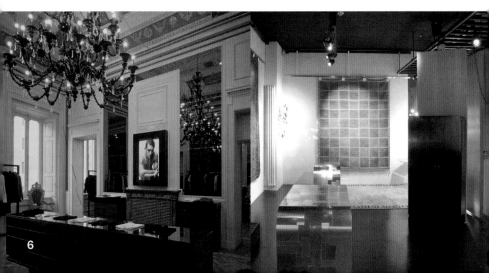

Einleitung

Die norditalienische Finanz- und Modemetropole zeichnet sich durch einen Lebensstil zwischen Kunst und Kommerz aus. Mailand ist eine Schaufensterstadt, in der einem der Traum vom Luxus auf Schritt und Tritt begegnet. Die Geschäfte lassen wahrlich keinen Wunsch offen! Die Welt der Mode und des Designs feiert sich vor allem im edlen Quadrilatero, dem „goldenen Viereck" zwischen Via Montenapoleone, Via della Spiga, Corso Venezia und Via Sant'Andrea. An diesem magischen und gleichzeitig äußerst realen Ort übertrumpft eine Eitelkeit die andere, und dicht an dicht drängen sich die luxuriösen Läden, deren Innenarchitektur und Schaufensterdekoration sich zu einer Art Galeriegang summieren. Weltweit bekannte Unternehmen wie Armani, Gucci oder B&B Italia beauftragen mit der Gestaltung ihrer Shops renommierte internationale Design-Ikonen, die es verstehen, Marken- und Unternehmensideen durch Architektur und Design fantasievoll zu übersetzen und Produkte perfekt zu inszenieren. Aber auch unbekanntere Läden wie Spazio 900, Dovetusai oder I Pinco Pallino fungieren dank ihres außergewöhnlichen Designs als „räumliche Logos". Der Bereich des Shop-Designs ist konstanten Erneuerungsprozessen unterworfen. Der Handel hat sich in den vergangenen Jahren verändert – und mit ihm der Verbraucher, der anspruchsvoll und konsumverwöhnt nach Zusatzwerten und Erlebnissen sucht. Mit dem wachsenden Überangebot wird es immer wichtiger, der Mode einen Mehrwert zu verleihen. Kleidung und Objekte müssen in Szene gesetzt und der Einkauf im ästhetischen Ambiente zu einem sinnlichen Erleben werden. Die Art der Präsentation hebt die Produkte aus der Sphäre des reinen Gebrauchswertes heraus und signalisiert damit Individualität. Anhand von 35 Läden belegt *Cool Shops Milan* eine Vielfalt der Stile. Der strenge Minimalismus der vergangenen Jahre wird von einer Tendenz überholt, die die Idee des Luxus und der kostbaren Raffinesse in den Vordergrund stellt.

Caroline Klein

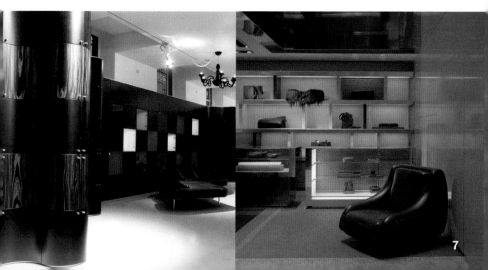

Introduction

L'art et le commerce caractérisent la mentalité de la métropole de la finance et de la mode du Nord de l'Italie. Milan est une grande vitrine débordante d'un luxe auquel on ne peut échapper. Dans les magasins milanais, pas un vœu qui ne puisse être exaucé ! Le monde de la mode et du design se fête principalement dans le beau Quadrilatero, le « carré d'or » qui se trouve entre la Via Montenapoleone, la Via della Spiga, le Corso Venezia et la Via Sant'Andrea. Ce haut lieu magique et en même temps bien réel se surpasse en frivolités dans les boutiques de luxe qui se pressent les unes contre les autres. L'architecture intérieure et la décoration des vitrines font penser à des galeries d'art. Des maisons de réputation mondiale comme Armani, Gucci ou B&B Italia confient l'aménagement de leurs magasins à des icônes internationales du design. Avec imagination et savoir-faire, ces créateurs donnent forme à des idées de marque et d'entreprise en utilisant l'architecture et le design pour présenter les articles dans un cadre parachevé. De même, des boutiques moins connues comme Spazio 900, Dovetusai ou I Pinco Pallino se distinguent par un design original qui fait figure de logo. Le shop-design est un domaine soumis à un processus de renouvellement permanent. Ces dernières années, le commerce a changé, et avec lui le consommateur qui, exigeant et gâté, est toujours en quête de nouvelles découvertes et sensations. Face à l'offre croissante, il est de plus en plus important de donner à la mode une plus-value. Les vêtements et les objets doivent être mis en scène pour que les achats se déroulent dans une ambiance esthétique et qu'ils soient une source de plaisir. Ainsi le mode de présentation vise à sortir les produits de leur sphère purement utilitaire et à souligner leur individualité. Avec ses 35 magasins, *Cool Shops Milan* témoigne d'une grande diversité de styles. Une nouvelle tendance a succédé au minimalisme sévère des années passées : c'est le souci du luxe et du raffinement qui domine aujourd'hui la scène.

Caroline Klein

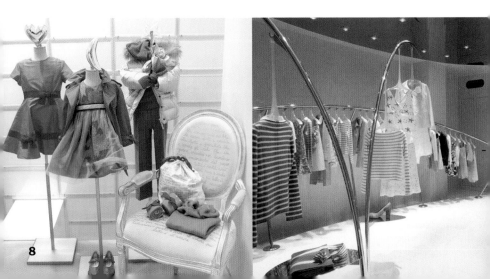

Introducción

La metrópoli financiera y de la moda del norte de Italia se caracteriza por un estilo de vida entre el arte y el comercio. Milán es una ciudad escaparate en la que uno se encuentra a cada paso con el sueño del lujo. ¡Las tiendas no dejan efectivamente ningún deseo pendiente! El mundo de la moda y del diseño se festeja sobre todo en el noble Quadrilatero, el "cuadrilátero dorado", entre la Via Montenapoleone, la Via della Spiga, el Corso Venezia y la Via Sant'Andrea. En este lugar mágico, y al mismo tiempo extremadamente real, una vanidad supera con holgura a la otra, las tiendas lujosas se apiñan unas junto a otras y su arquitectura interior y la decoración de sus escaparates se acumula en una especie de paso por una galería. Marcas conocidas mundialmente como Armani, Gucci o B&B Italia encargan la configuración de sus tiendas a iconos del diseño con prestigio internacional que saben traducir con fantasía las ideas de las marcas y las empresas por medio de la arquitectura y del diseño y poner en escena los productos perfectamente. Pero también tiendas menos conocidas como Spazio 900, Dovetusai o I Pinco Pallino funcionan como "logos del espacio" gracias a su diseño excepcional. El terreno del shop design está sometido a procesos de renovación constantes.
El comercio ha cambiado en los pasados años y con él el consumidor quien, exigente y mimado por el consumo, busca valores adicionales y experiencias. Con el creciente exceso de la oferta se vuelve cada vez más importante dotar a la moda de una mayor valía. La ropa y los objetos tienen que ponerse en escena y la compra en el ambiente estético debe convertirse en una vivencia sensual. El modo de la presentación destaca los productos de la esfera de su puro valor de uso señalando con ello individualismo. Por medio de 35 tiendas *Cool Shops Milan* documenta una variedad de los estilos. El minimalismo estricto de los años pasados es superado por una tendencia que pone en un primer plano la idea del lujo y de la sofisticación valiosa.

Caroline Klein

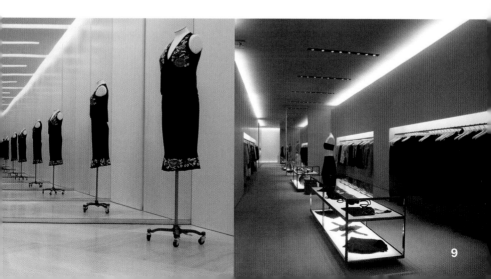

10 Corso Como

Design: Kris Ruhs

Corso Como 10 | 20154 Milan | Brera, Porta Garibaldi
www.10corsocomo.com
Phone: +39 02 29002674
Opening year: 1991
Opening hours: Mon 3:30 pm to 7:30 pm; Tue, Fri, Sat and Sun 10:30 am to 7:30 pm;
Wed and Thu 10:30 am to 9 pm
Subway: Moscova, Porta Garibaldi
Products: Books, perfume, fashion, shoes, gifts
Special features: Events, exhibitions

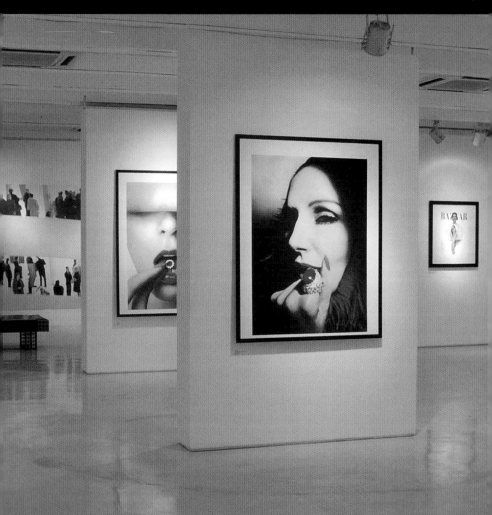

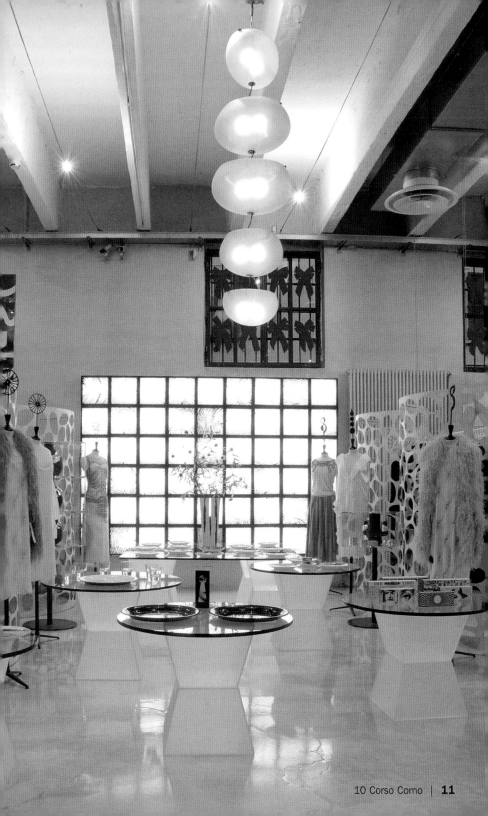

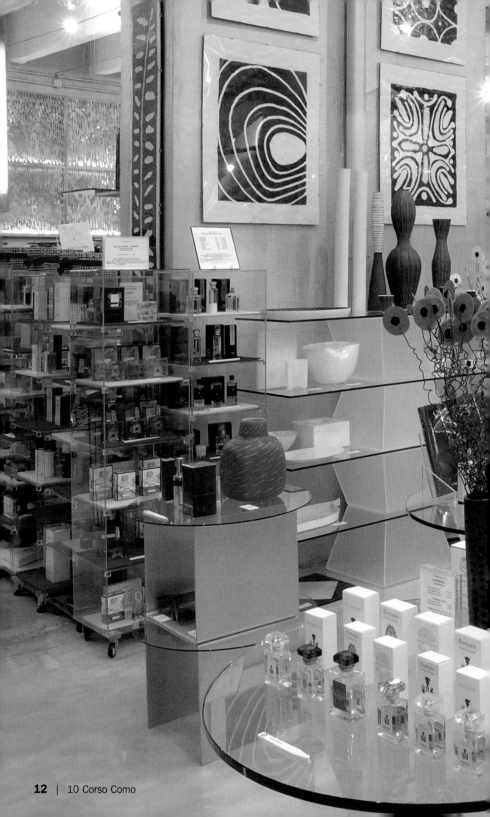

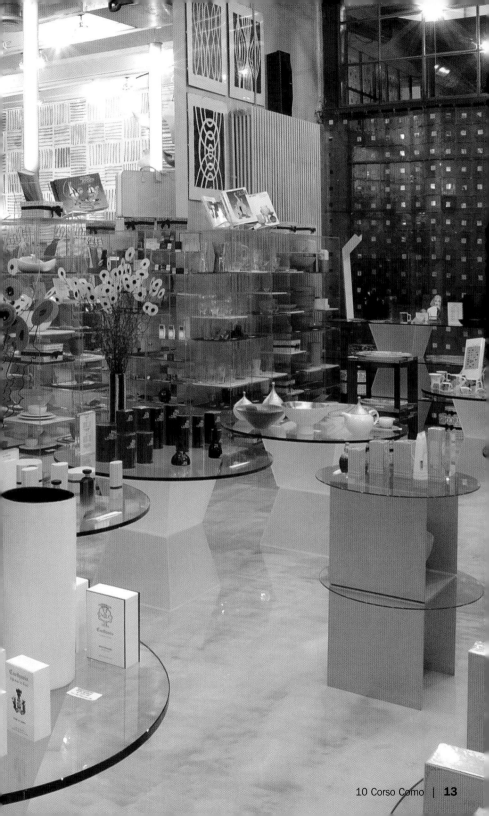

Acqua di Parma

Via Gesù 3 | 20121 Milan | Quadrilatero
www.acquadiparma.com
Phone: +39 02 76023307
Opening year: 1998
Opening hours: Tue–Sat 10 am to 7 pm, Mon 3 pm to 7 pm
Subway: Manzoni
Products: Perfume, lifestyle collections, gifts
Special features: Hat box, holiday special

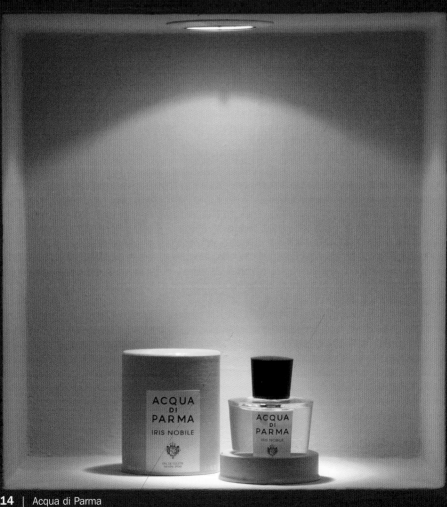

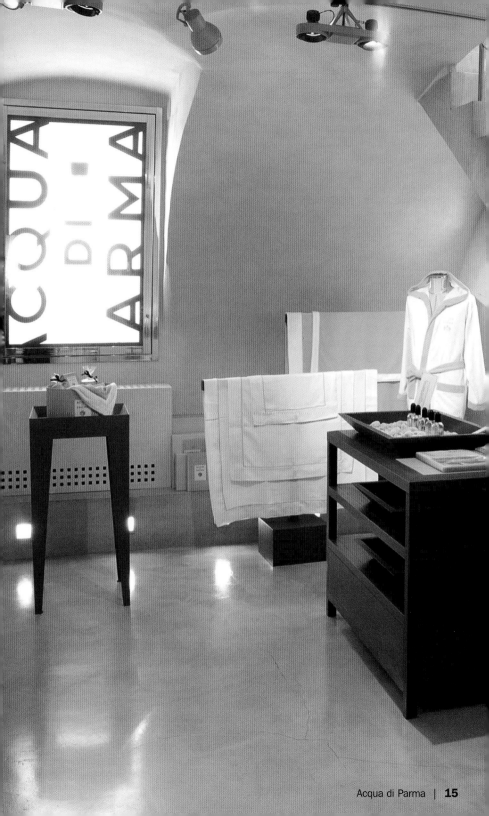

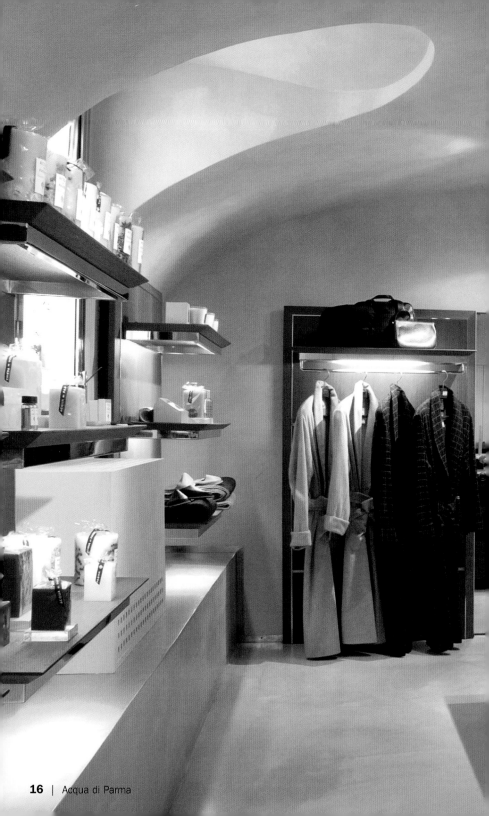

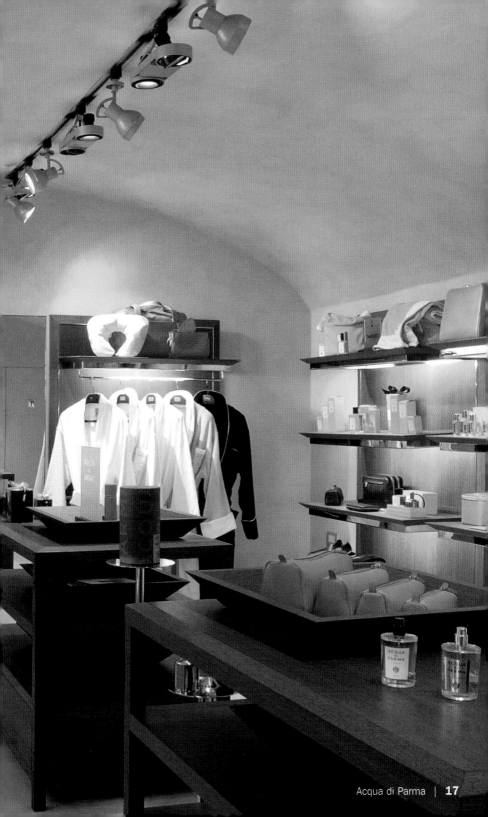

Anna Molinari – Blumarine

Design: Tony Cordero

Via della Spiga 42 | 20121 Milan | Quadrilatero
www.blufin.it
Phone: +39 02 795081
Opening year: 1990
Opening hours: Tue–Sun 10 am to 13:30 pm, 3 pm to 7 pm, Mon closed
Subway: Palestro
Products: Anna Molinari and Blumarine collections

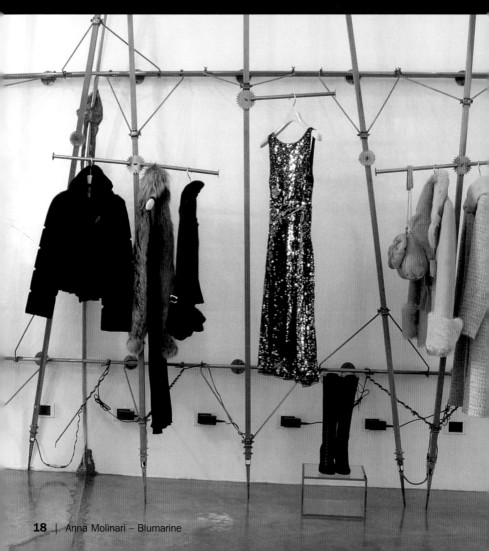

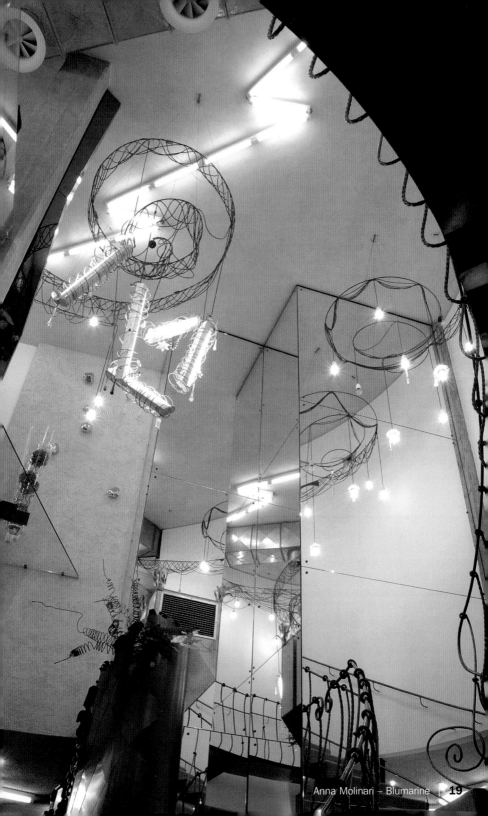

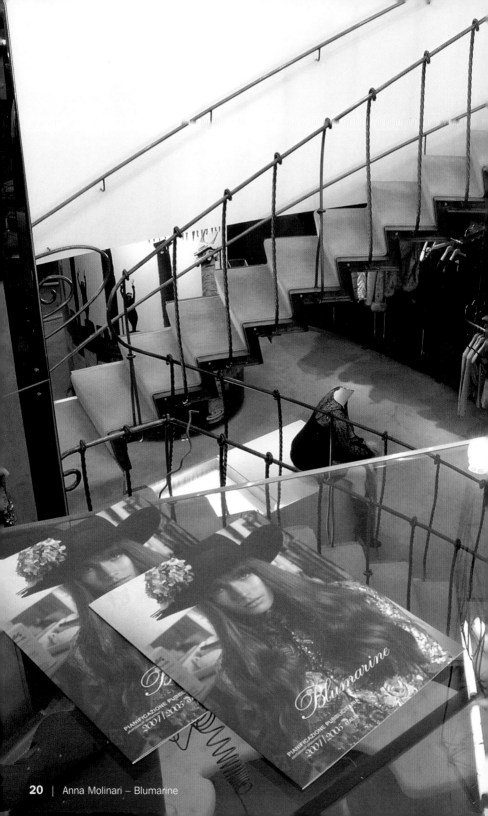

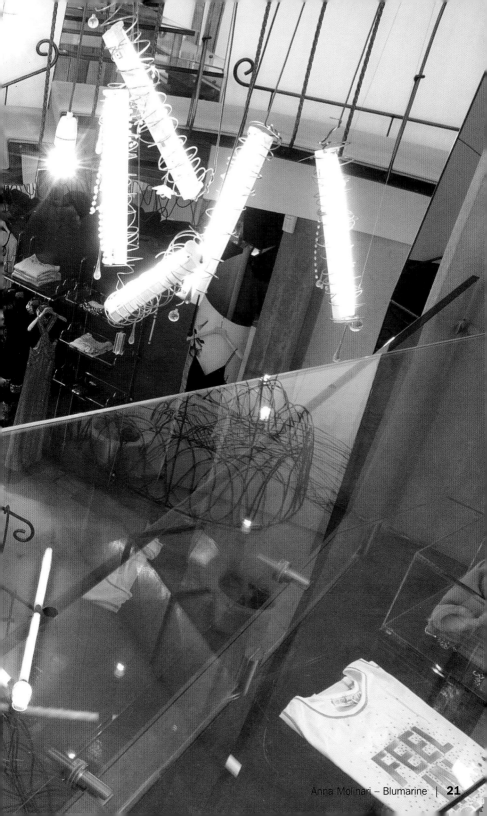

B&B Italia Store

Design: Antonio Citterio and Partners – Antonio Citterio with Patricia Viel

Via Durini 14 | 20122 Milan | San Babila
www.bebitalia.it
Phone: +39 02 764441
Opening year: 2002
Opening hours: Tue–Sat 10 am to 7 pm, Mon 3 pm to 7 pm
Subway: San Babila
Products: Furniture, books, objects

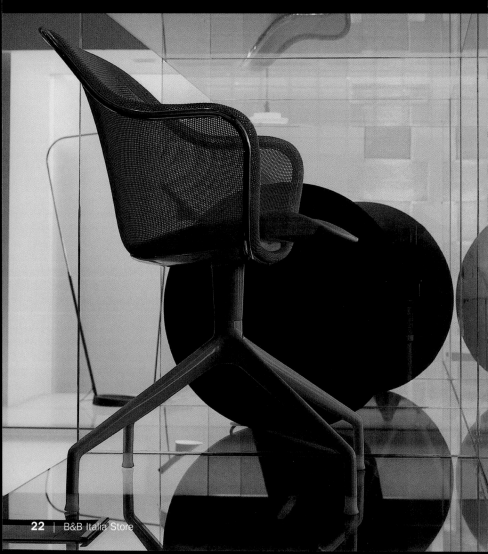

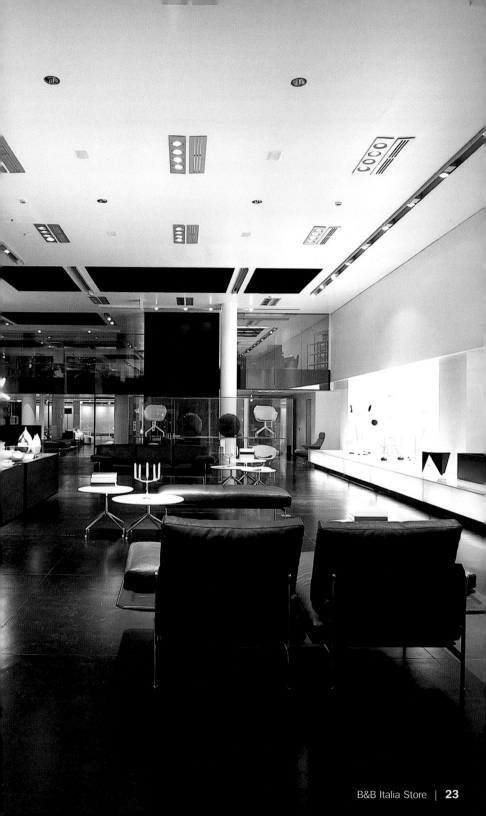

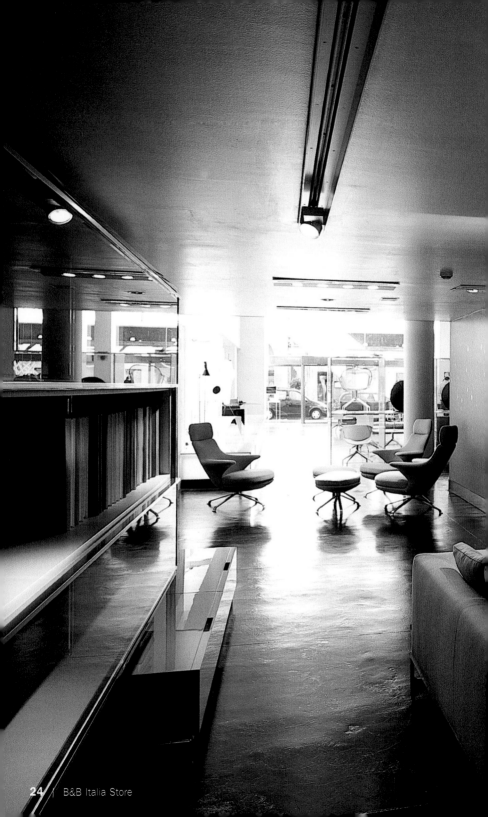

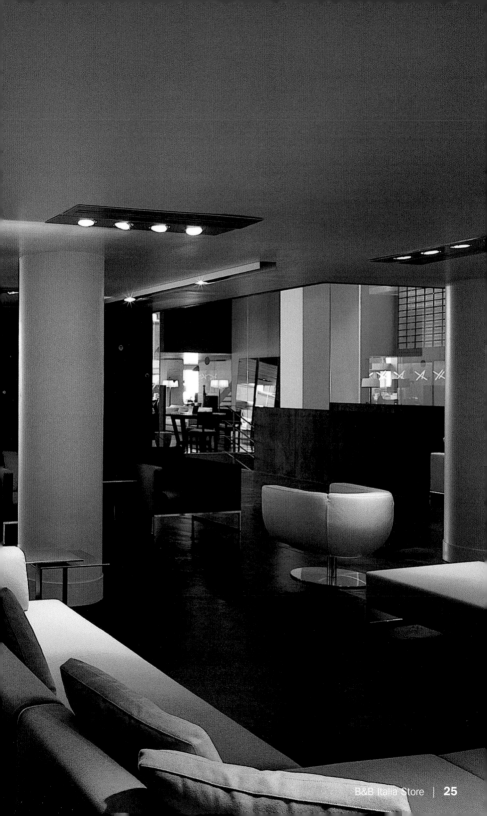

Boffi

Design: Piero Lissoni

Via Solferino 11 | 20121 Milan | Brera
www.boffi.com
Phone: +39 02 8790991
Opening hours: Tue–Sat 10 am to 7 pm, Mon closed
Subway: Moscova
Products: Bathroom and kitchen furniture, illumination, accessories

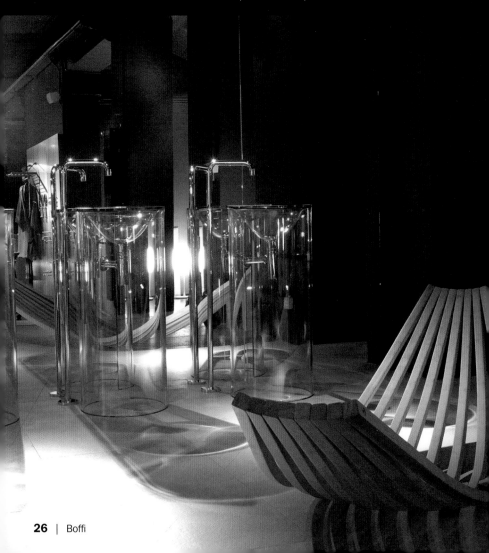

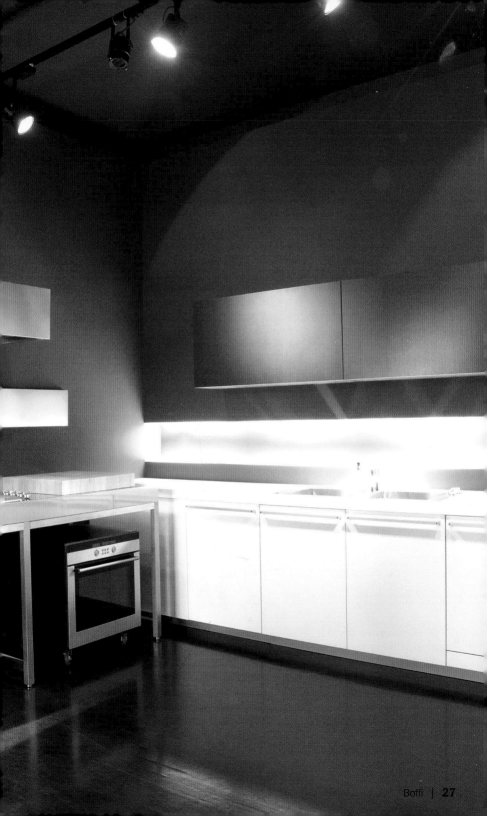

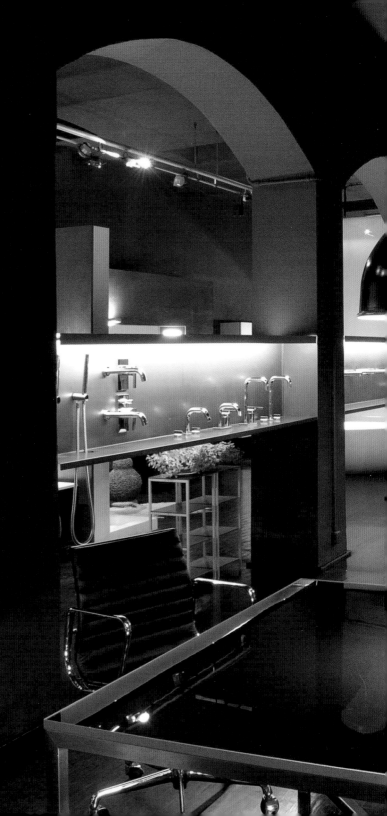

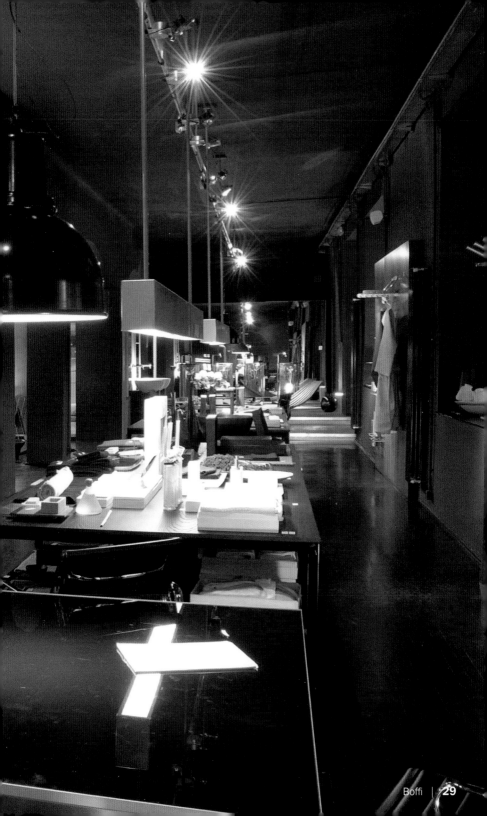

Clone – **Bruno Bordese**

Design: Bruno Bordese

Corso Venezia 6 | 20121 Milan | San Babila
www.clone-italia.com
Phone: +39 02 76001136
Opening year: 1997
Opening hours: Tue–Sat 10 am to 7 pm, Mon 3 pm to 7 pm
Subway: San Babila
Products: Shoes

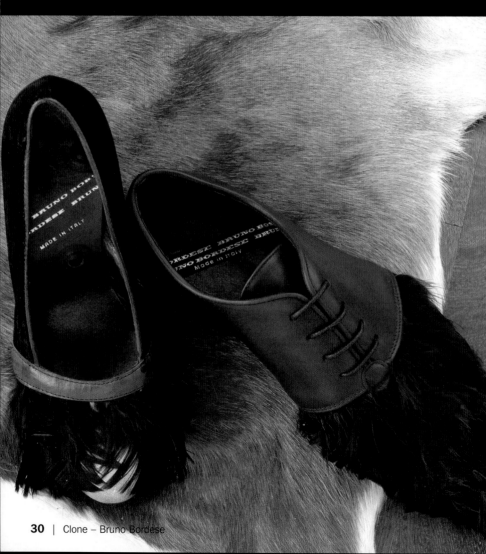

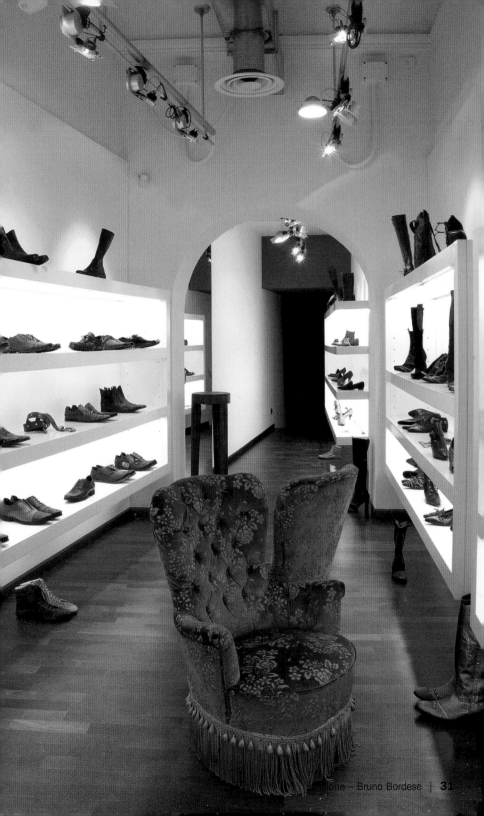

Costume National

Design: Ennio Capasa

Via Sant' Andrea 12 | 20121 Milan | Angolo Montenapoleone
www.costumenational.com
Phone: +39 02 76018356
Opening year: 1997
Opening hours: Mon–Sun 10 am to 7 pm
Subway: Montenapoleone
Products: Women's wear, men's wear, shoes, accessories

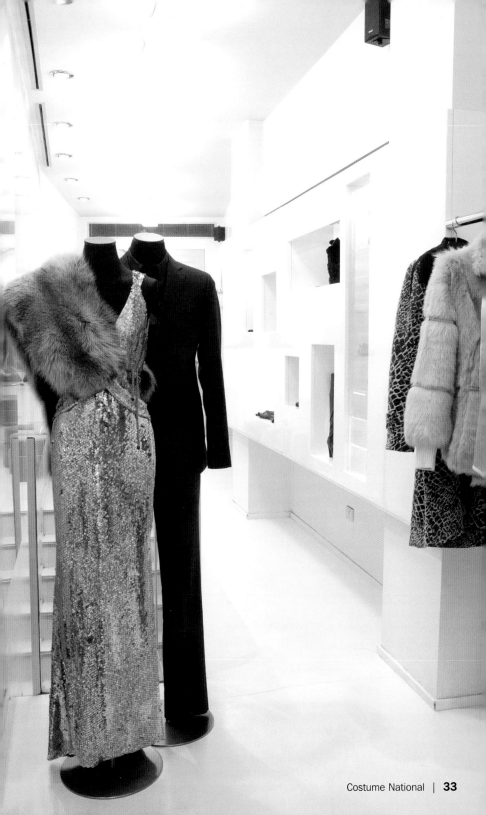

Culti

Design: Alessandro Agrati

Corso Venezia 53 | 20100 Milan | Quadrilatero
www.culti.it
Phone: +39 02 780637
Opening year: 1998
Opening hours: Mon–Sat 10 am to 1 pm and 2 pm to 7 pm
Subway: Palestro
Products: Furniture, lighting systems, objects, textiles, outdoor furniture,
clothing, fashion accessories, home and person perfumes

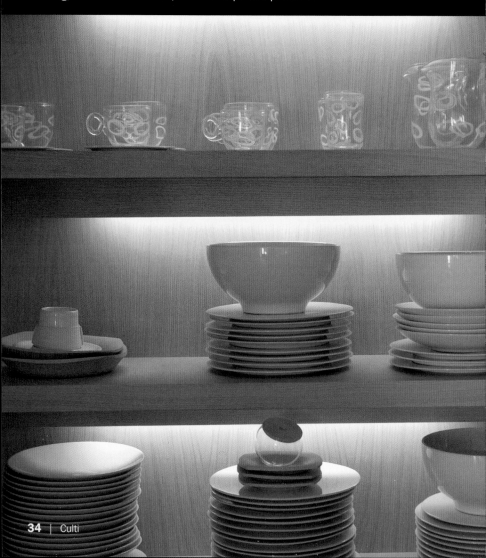

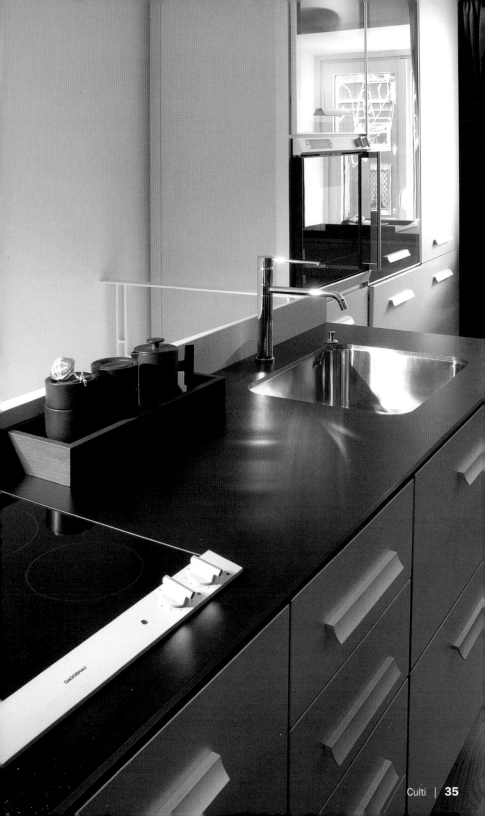

Da Driade

Via Manzoni 30 | 20121 Milan | Quadrilatero
www.driade.com
Phone: +39 02 76023098
Opening year: 1994
Opening hours: Tue–Sat 10 am to 7 pm, Mon 3 pm to 7 pm
Subway: Montenapoleone
Products: Furniture, accessories, illumination
Special features: Events, exhibitions

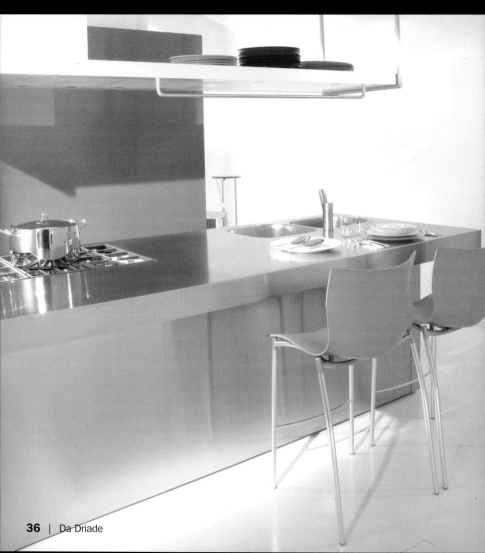

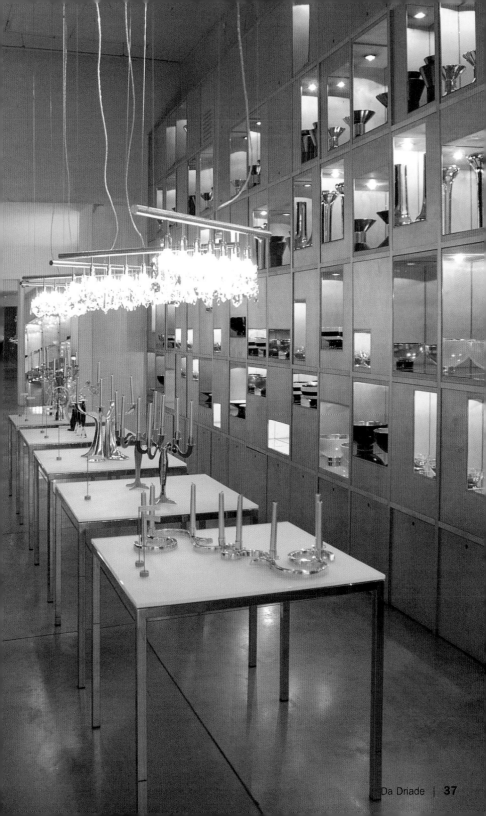

De Padova

Corso Venezia 14 | 20121 Milan | San Babila
www.depadova.it
Phone: +39 02 777201
Opening year: 1965
Opening hours: Tue–Sat 10 am to 7 pm, Mon 3 pm to 7 pm
Subway: San Babila
Products: Furniture, design accessories
Special features: Events, exhibitions

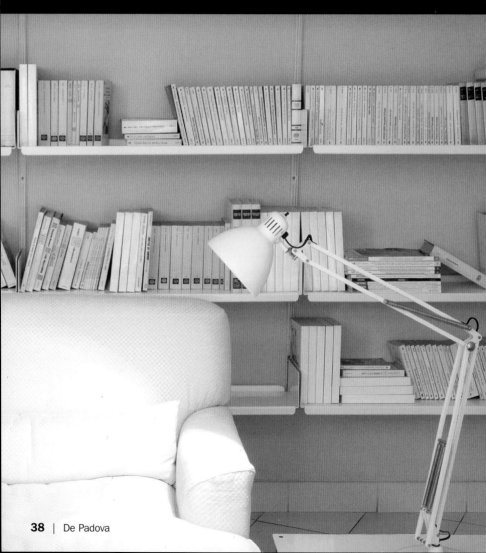

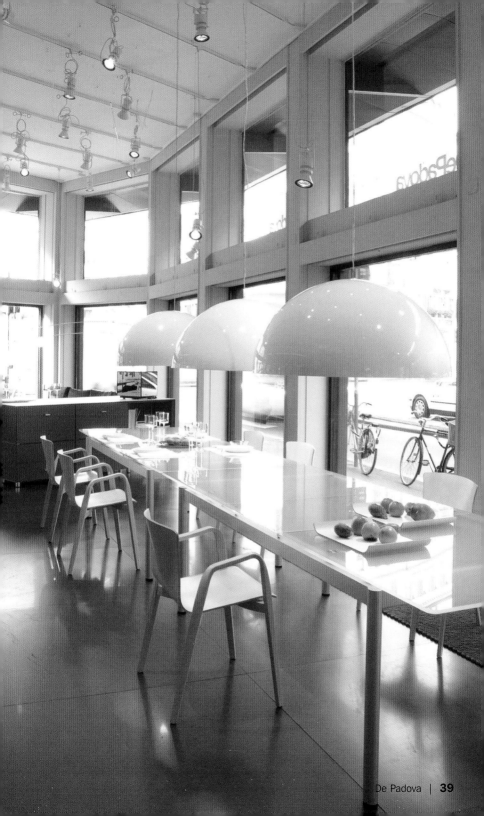

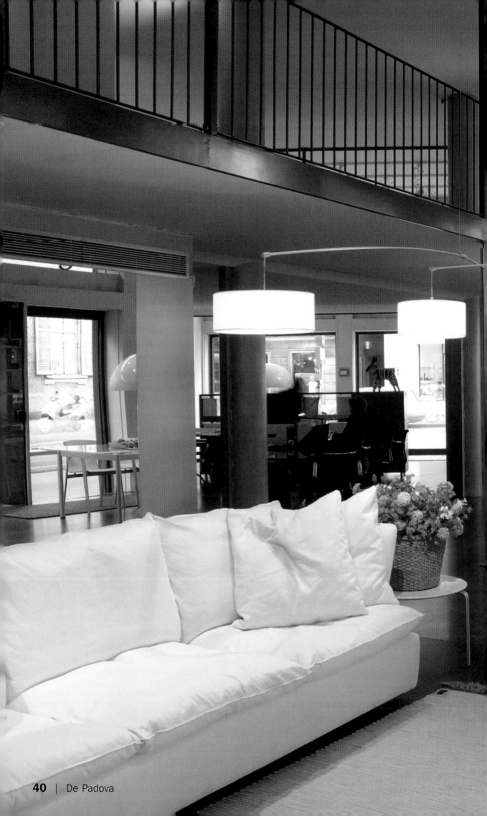

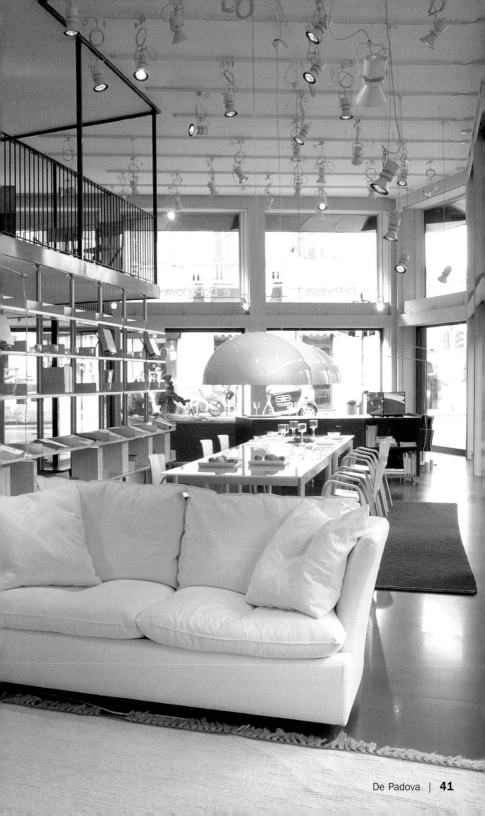

Dolce & Gabbana Donna

Design: David Chipperfield, Ferruccio Laviani

Via della Spiga 26 | 20121 Milan | Quadrilatero
www.dolcegabbana.it
Phone: +39 02 76001155
Opening year: 2004
Opening hours: Mon–Sat 10 am to 7 pm
Subway: San Babila, Montenapoleone
Products: Women's wear, accessories
Special features: VIP room

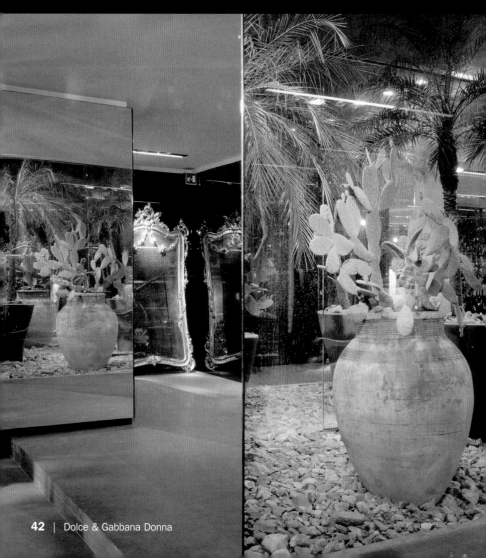

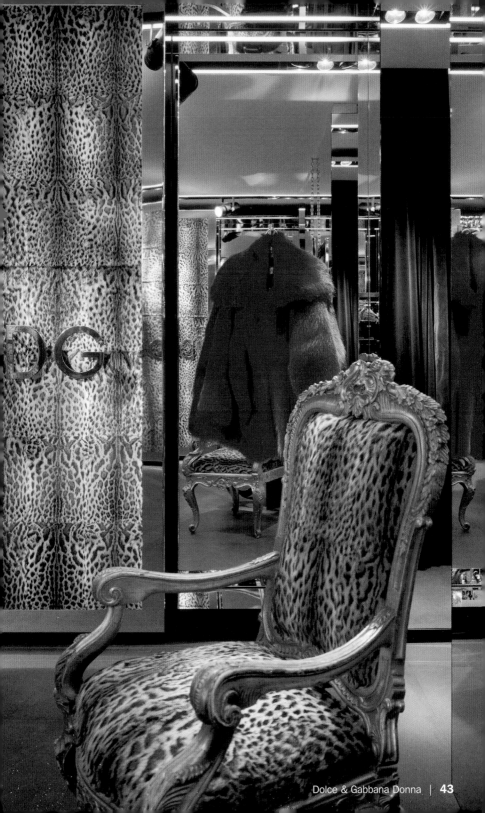

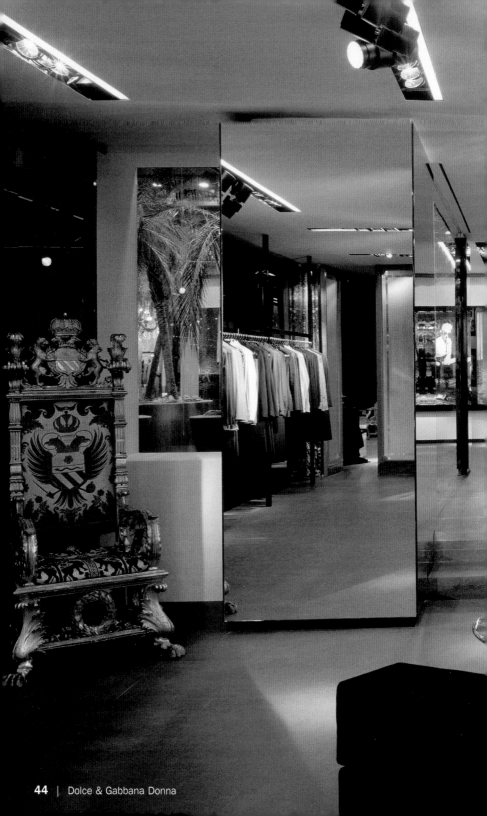

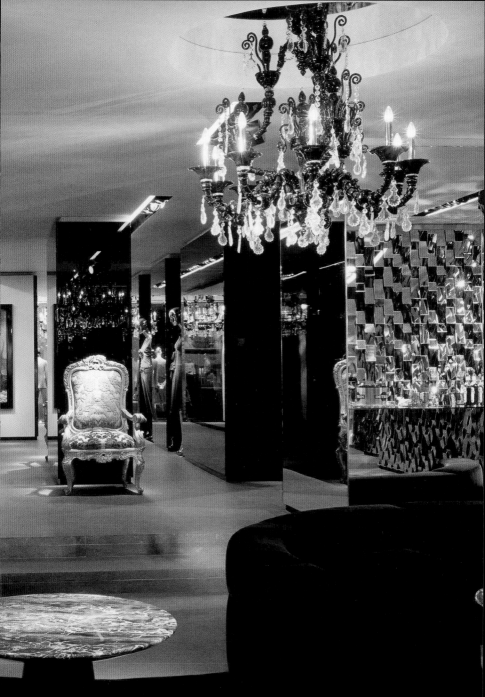

Dolce & Gabbana Uomo

Design: David Chipperfield, Ferruccio Laviani

Corso Venezia 15 | 20121 Milan | San Babila
www.dolcegabbana.it
Phone: +39 02 76028485
Opening year: 2003
Opening hours: Mon–Sat 10 am to 7 pm
Subway: San Babila
Products: Men's wear
Special features: Barber, Martini bar, grooming

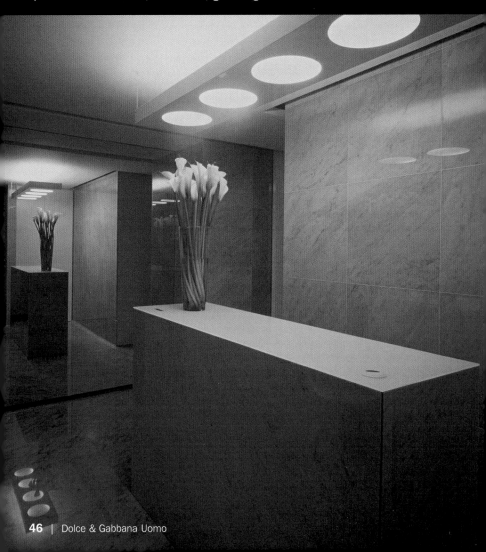

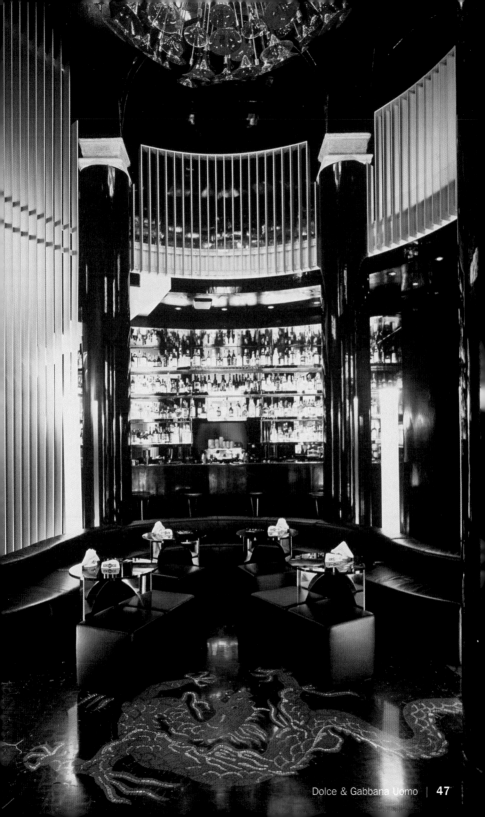

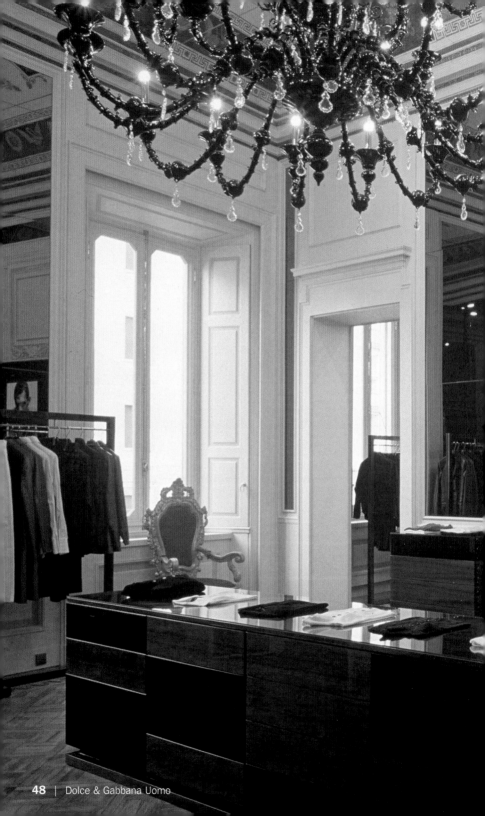

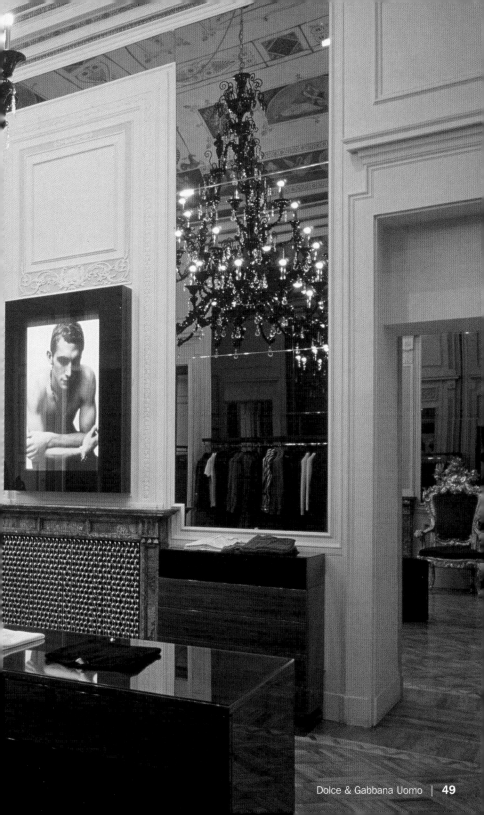

Dovetusai

Design: Fabio Cocchi, Luigi Rotta

Via Sigieri 24 | 20135 Milan | Porta Romana
www.dovetusai.it
Phone: +39 02 59902432
Opening year: 2000
Opening hours: Mon–Fri 10 am to 1 pm, 2:30 pm to 7 pm, Sat open from Oct–Dec
Subway: Lodi
Products: Small furniture, accessories, illumination
Special features: Events, exhibitions

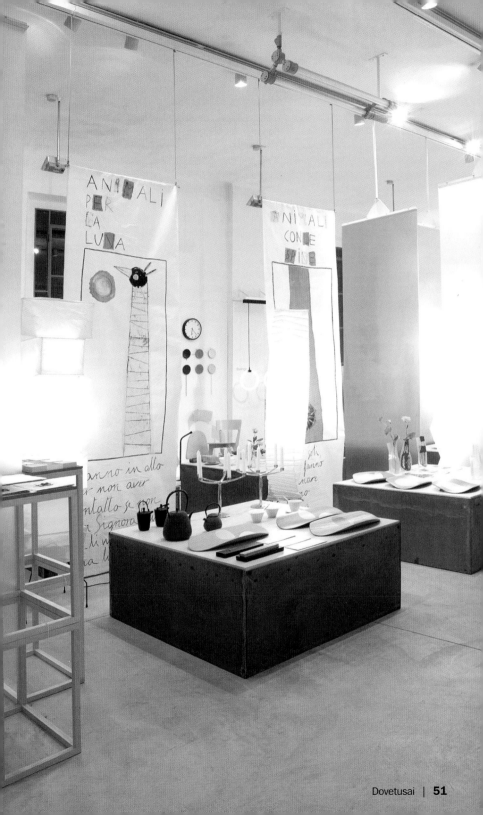

Edra

Design: Edra

Via Ciovassino 3 | 20121 Milan | Quadrilatero
www.edra.com
Phone: +39 02 86995122
Opening year: 2003
Opening hours: Mon–Sat 10 am to 1:30 pm, 2:30 pm to 7 pm
Subway: Montenapoleone
Products: Furniture

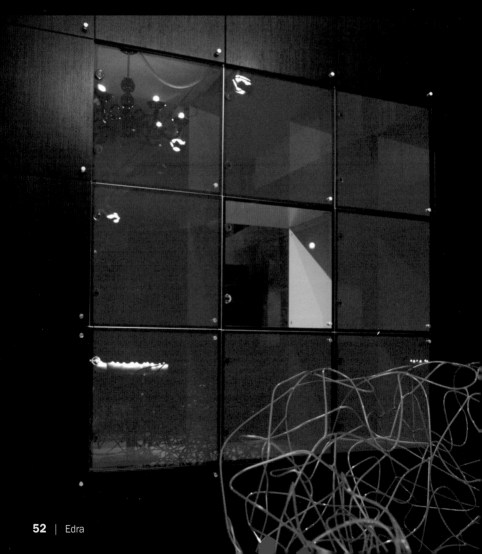

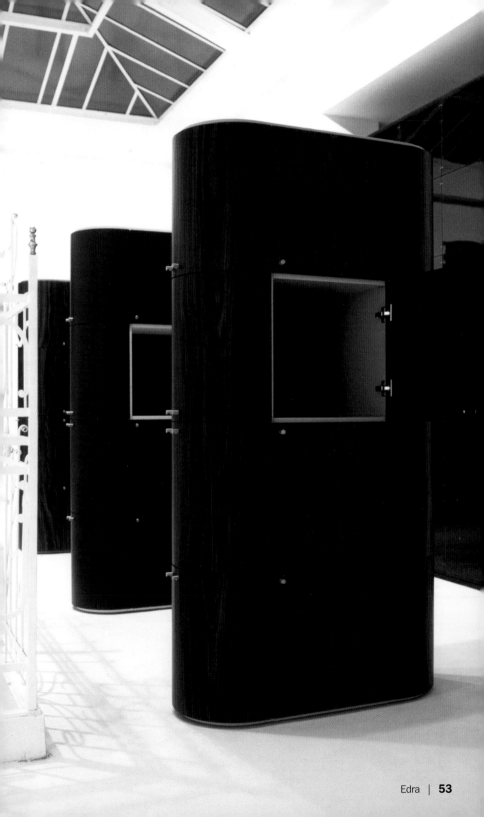

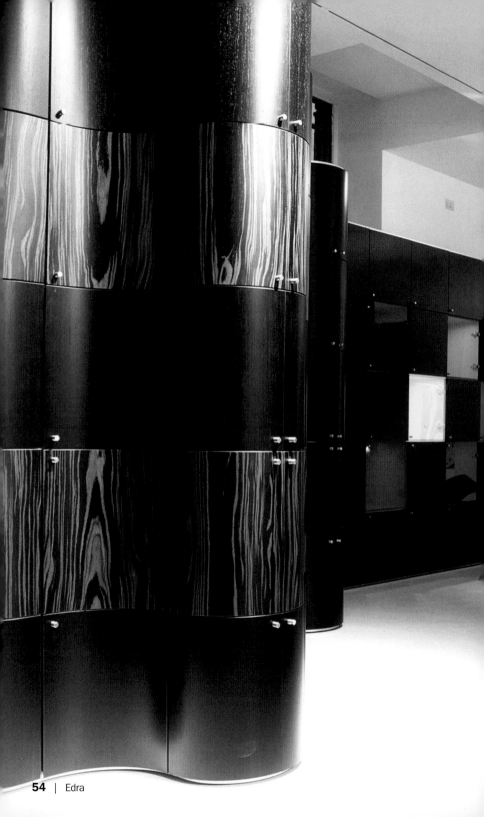

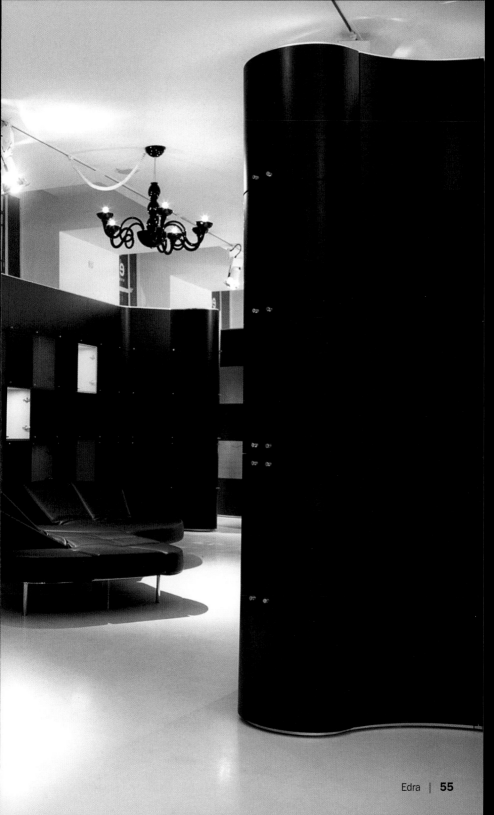

Fausto Santini

Design: Antonio Citterio and Partners, Antonio Citterio with Patricia Viel

Via Montenapoleone 1 | 20121 Milan | Quadrilatero
www.faustosantini.it
Phone: +39 02 76014356
Opening year: 1994
Opening hours: Tue–Sat 10 am to 7 pm, Mon 3 pm to 7 pm
Subway: San Babila, Montenapoleone
Products: Shoes

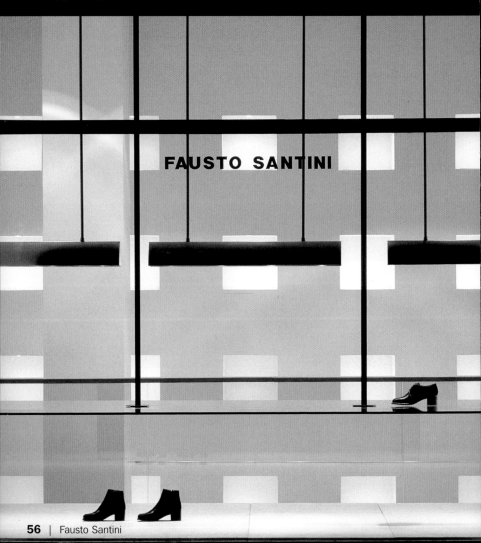

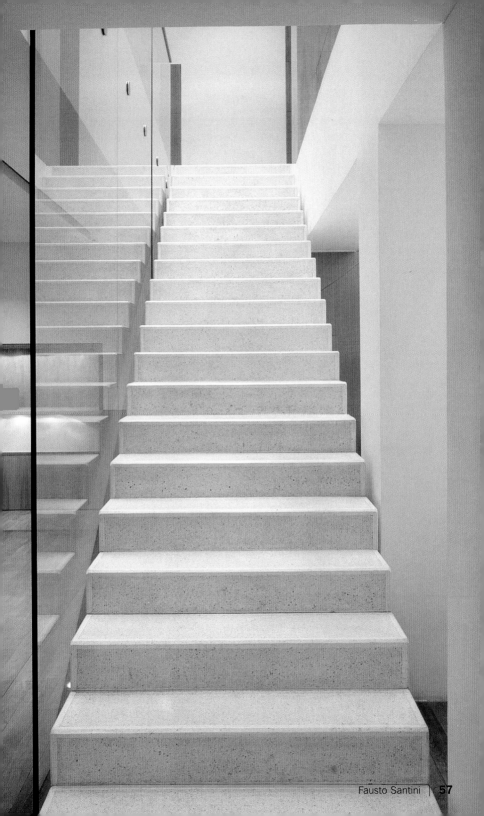

Galleria Nilufar

Design: Gian Carlo Montebello

Via della Spiga 30–32 | 20121 Milan | Quadrilatero
www.nilufar.com
Phone: +39 02 780193
Opening year: 1979
Opening hours: Mon 3 pm to 7:30 pm, Tue–Sat 10 am to 7:30 pm
Subway: Montenapoleone, San Babila
Products: Carpets, rare furnitures
Special features: Events, exhibitions

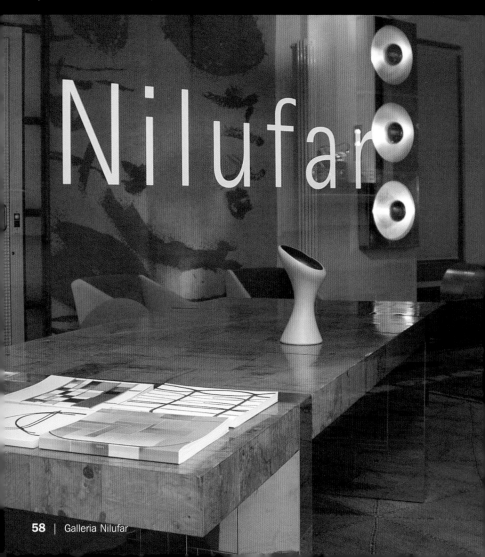

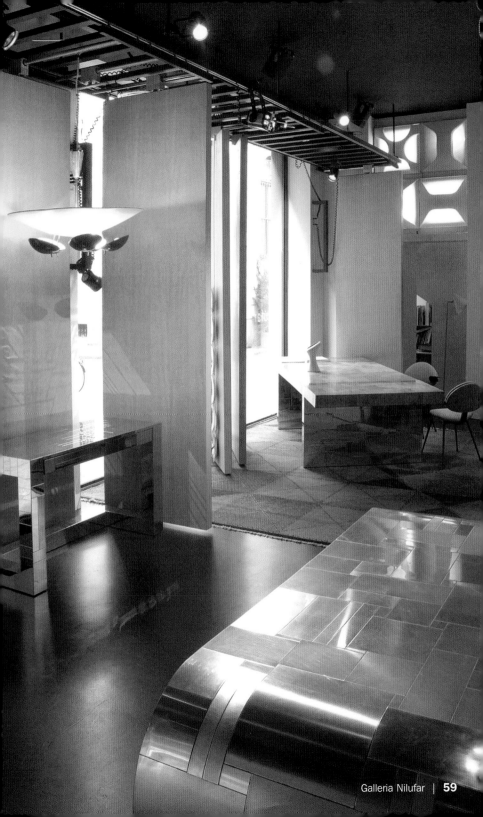

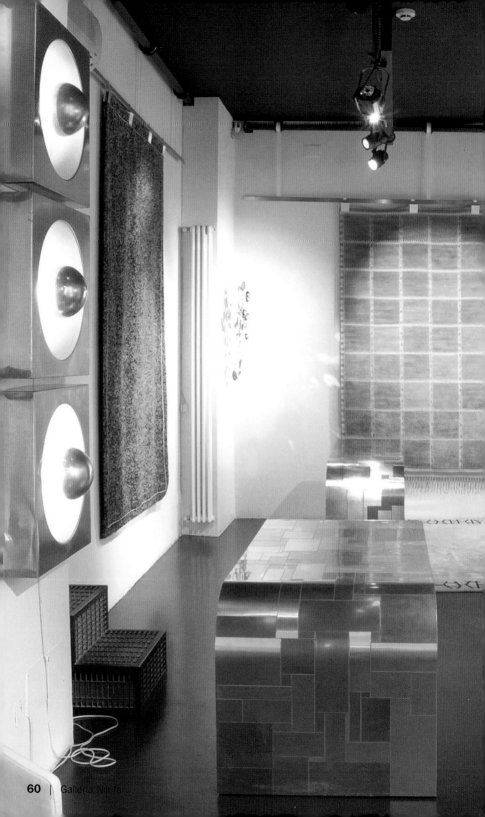

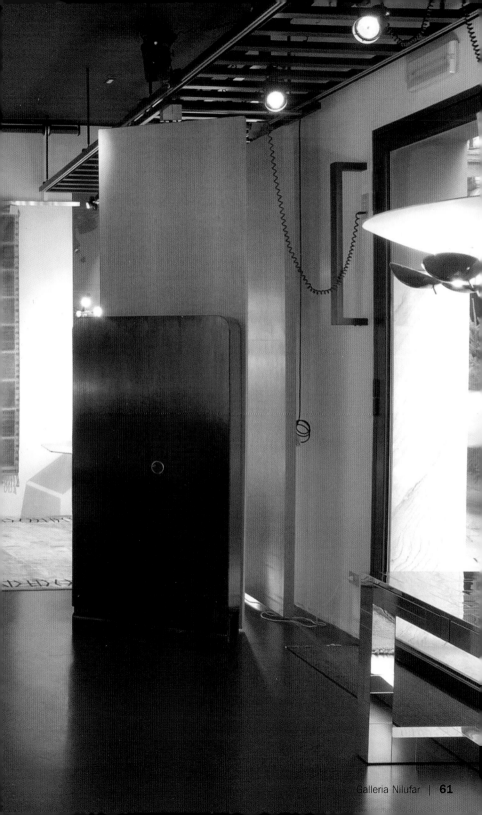

Giorgio Armani Milano

Design: Claudio Silvestrin Architects

Via Sant' Andrea 9 | 20121 Milan | Quadrilatero
www.giorgioarmani.it
Phone: +39 02 76003234
Opening hours: Mon–Sun 10:30 am to 7:30 pm
Subway: San Babila
Products: Fashion

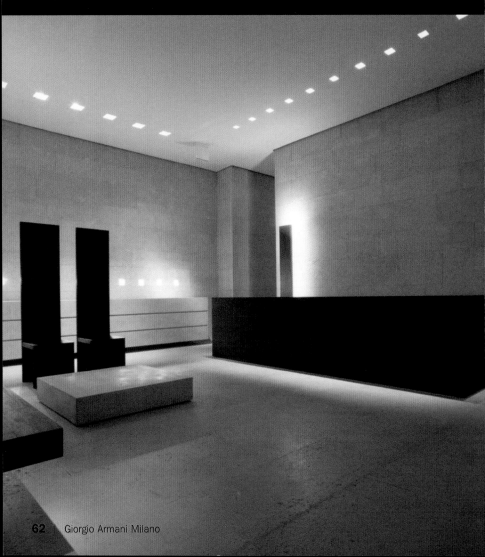

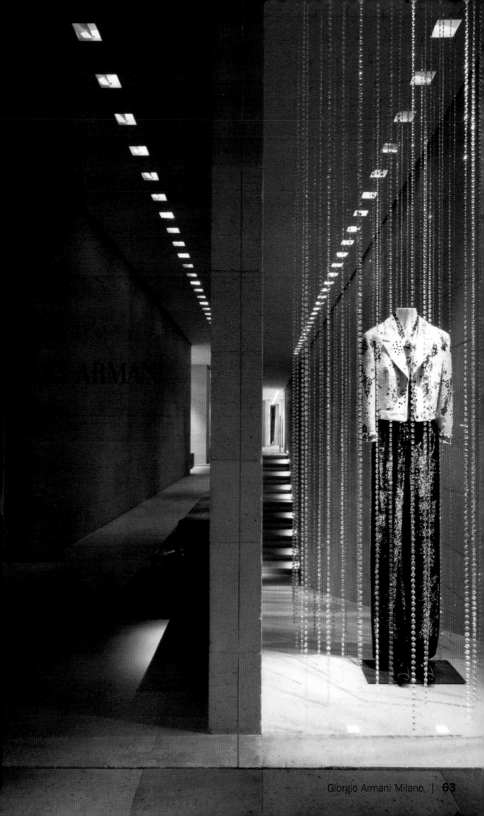

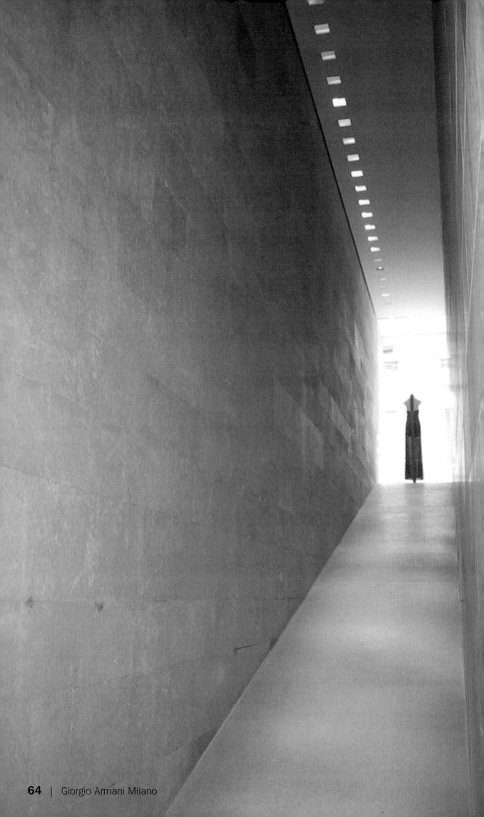

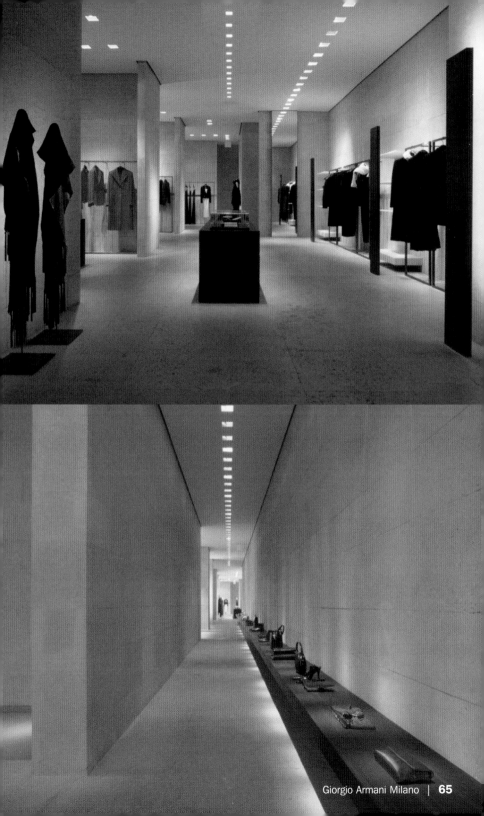

Gucci

Design: William Sofield

Via Montenapoleone 5 | 20121 Milan | Quadrilatero
www.gucci.com
Phone: +39 02 771271
Opening year: 2002
Opening hours: Mon–Sat 10 am to 7 pm
Subway: San Babila, Montenapoleone
Products: RTW, accessories, small leather bags, timepieces, jewelry, eyewear, gifts

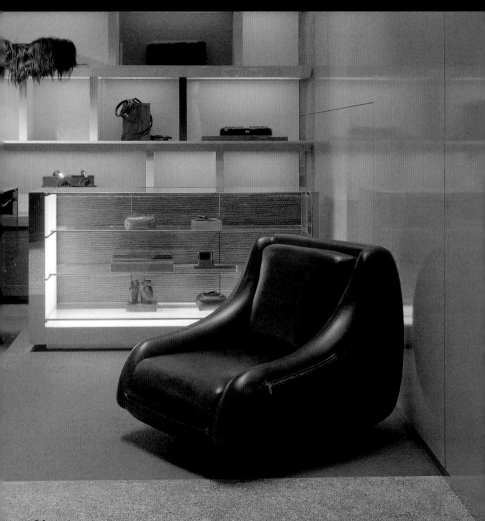

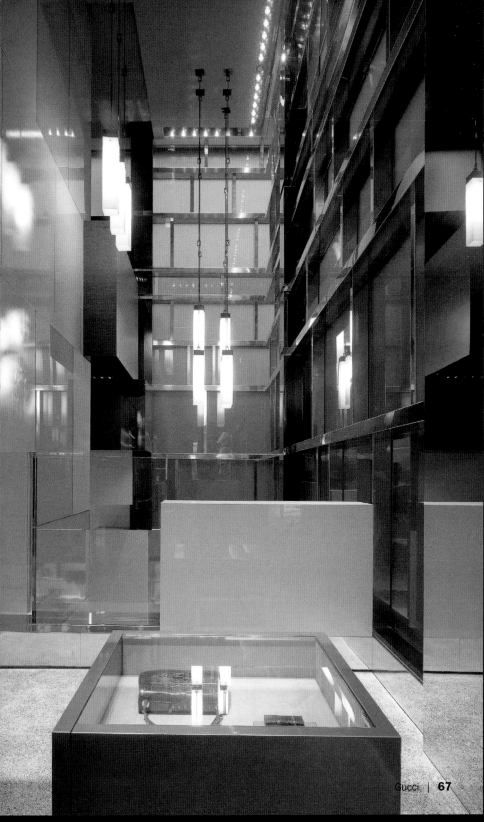

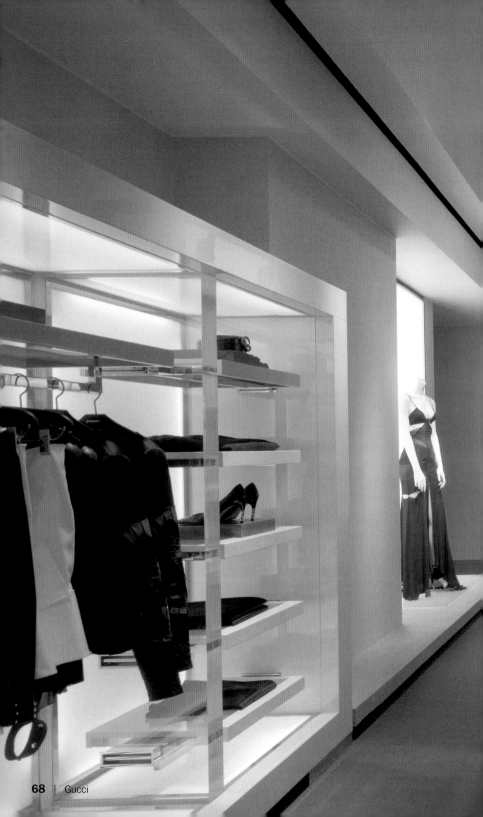

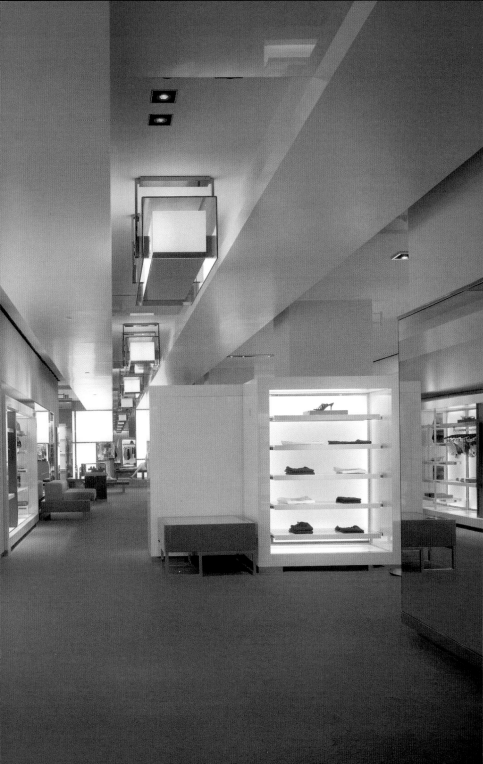

Habits Culti

Design: Alessandro Agrati

Via Angelo Mauri 5 | 20144 Milan | Vercelli
www.habitsculti.it
Phone: +39 02 48517286
Opening year: 2004
Opening hours: Mon–Sun 10 am to 10 pm
Subway: Conciliazione, Pagano
Products: Flowers, plants and flowerpots, home parfums and candles, food,
Spa and beauty products
Special features: Spa-Café

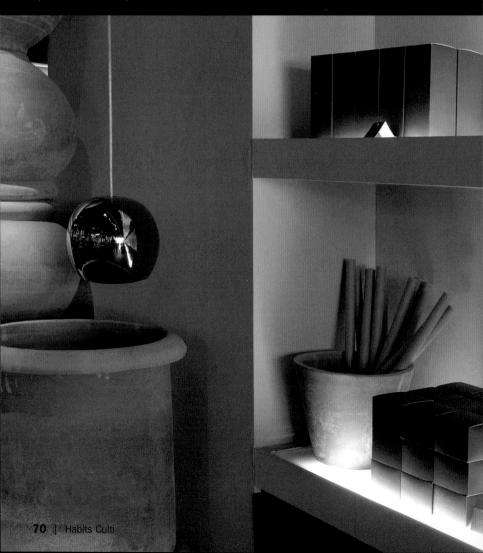

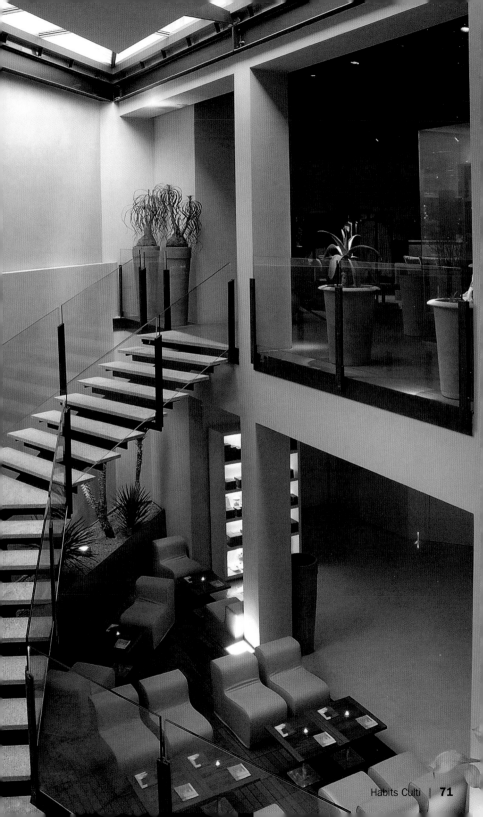

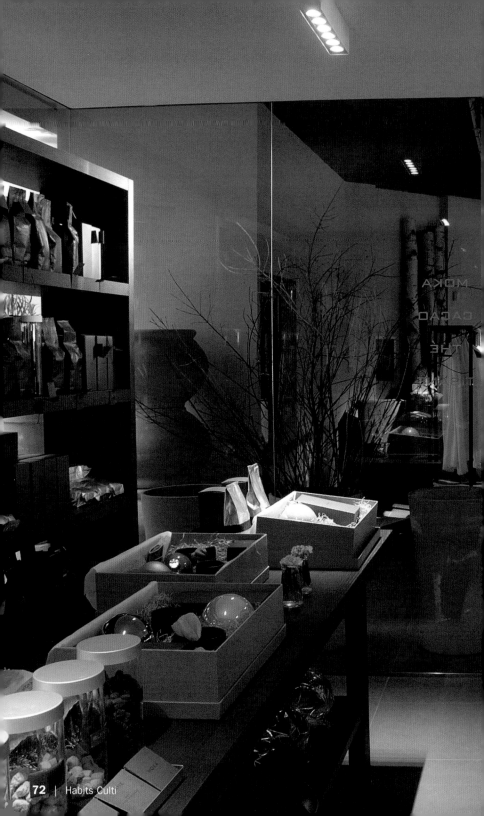

Il Salumaio

Design: Enrico Valeriani

Via Montenapoleone 12 | 20121 Milan | Quadrilatero
www.ilsalumaiodimontenapoleone.it
Phone: +39 02 76001123
Opening year: 1957
Opening hours: Every day 8:30 am to 1 pm, 3:30 pm to 7:30 pm
Subway: San Babila
Products: Food
Special features: Restaurant, catering

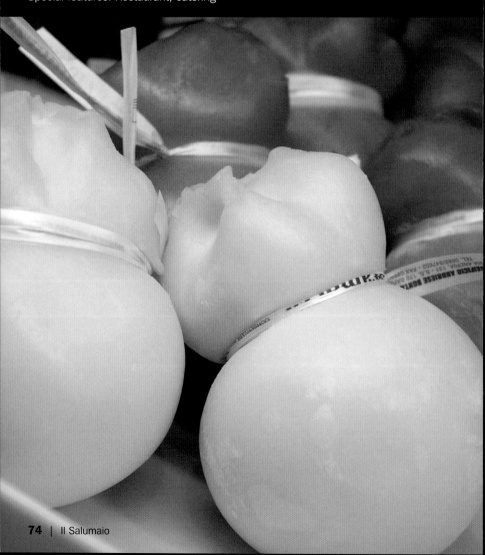

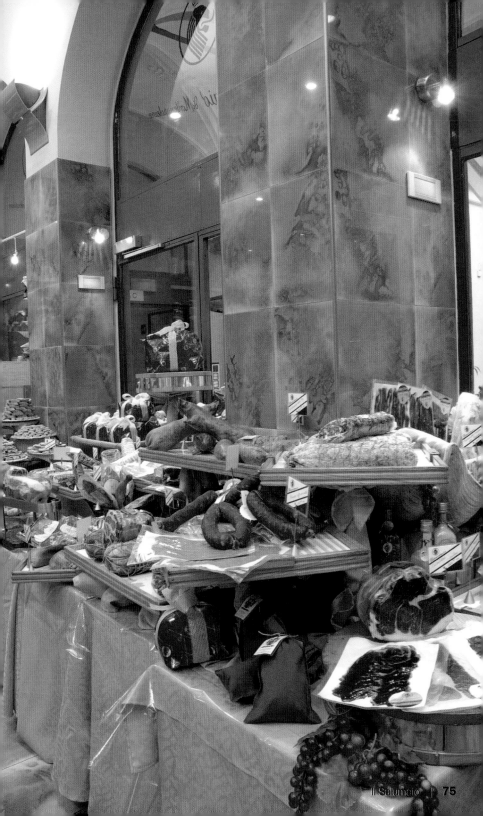

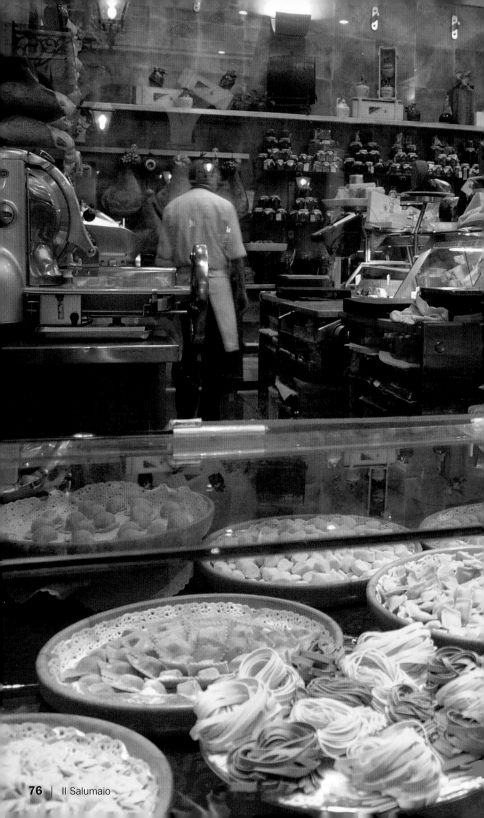

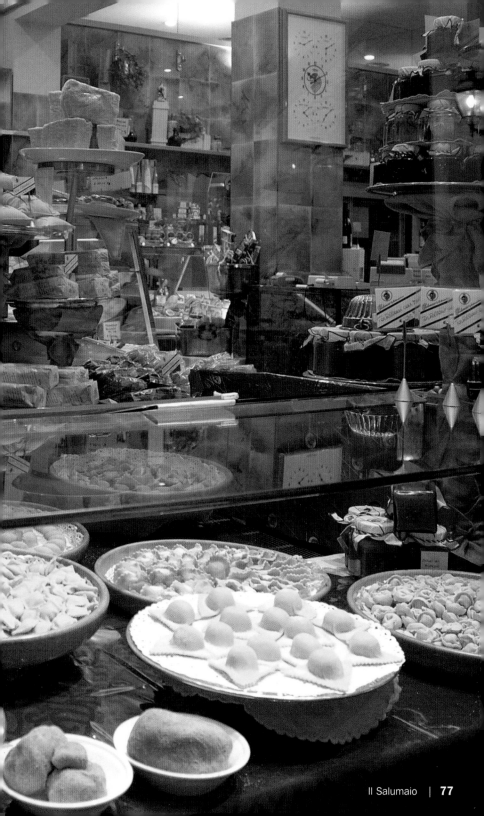

I Pinco Pallino

Design: Annamaria Scevola, Massimiliano Locatelli of
CLS Architetti Studio

Via della Spiga 42 | 20121 Milan | Quadrilatero
www.ipincopallino.it
Phone: +39 02 781931
Opening year: 1997
Opening hours: Mon 3 pm to 7 pm, Tue–Sat 10 am to 7 pm
Subway: Montenapoleone, San Babila
Products: Children's Fashion – I Pinco Pallino clothes, shoes, accessories

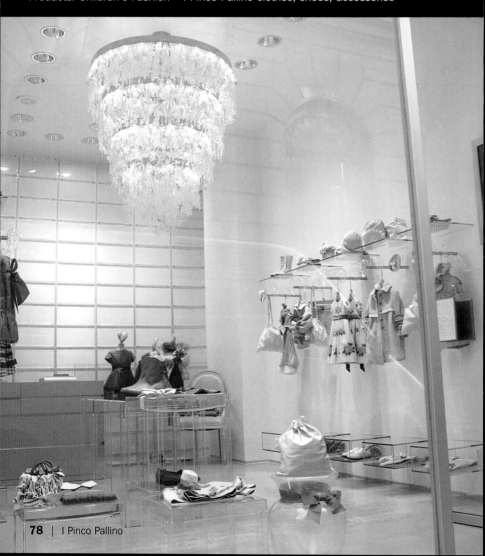

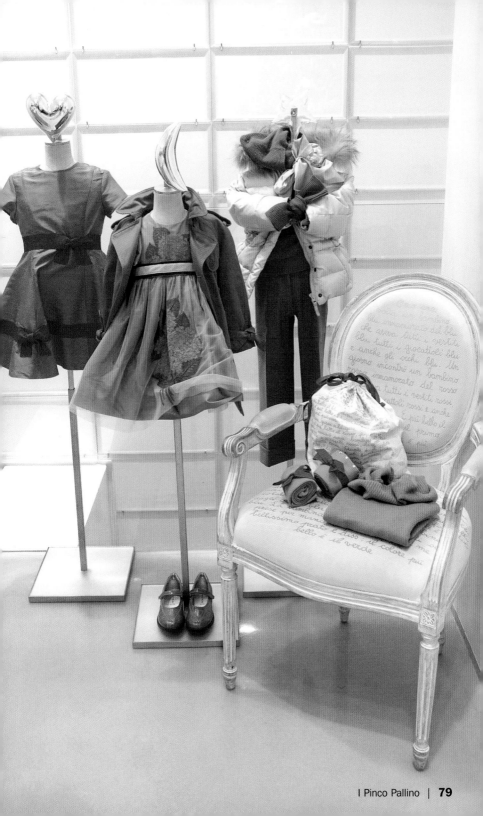

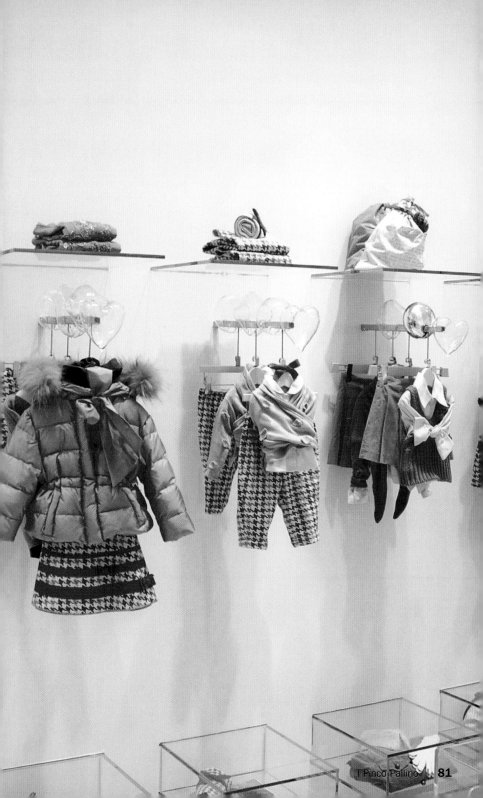

Lolli e Memmoli

Ivan Lolli, Mario Memmoli Architects

Via Vivarini 7 | 20141 Milan | Tibaldi
www.lollimemmoli.it
Phone: +39 02 89502342
Opening year: 2002
Opening hours: Mon–Fri 10 am to 1 pm, 2 pm to 7 pm
Subway: Famagosta
Products: Lighting
Special features: Every year, in April presentation of the new collection for the "Salone Internazionale del Mobile di Milano"

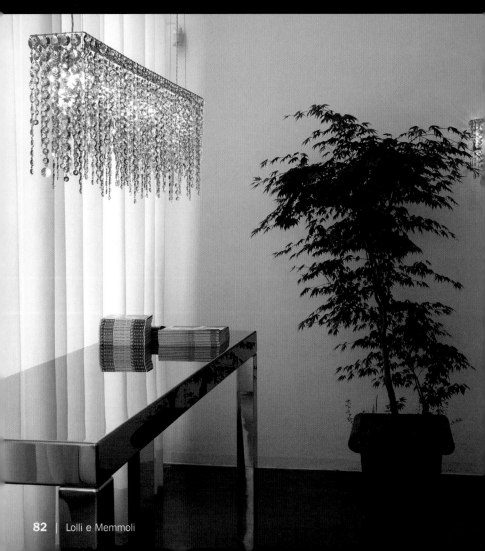

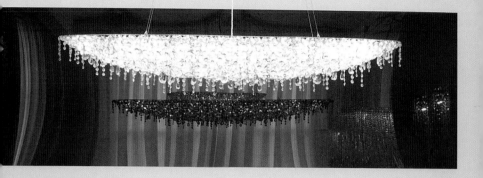

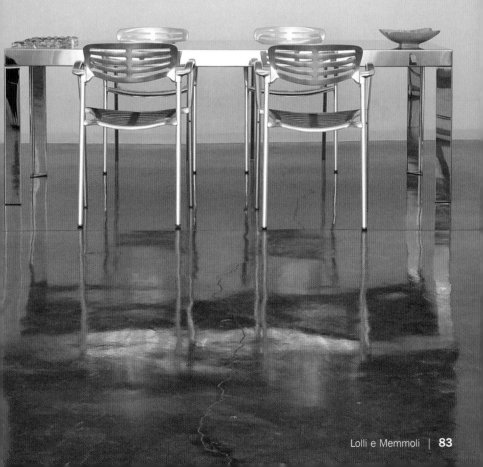

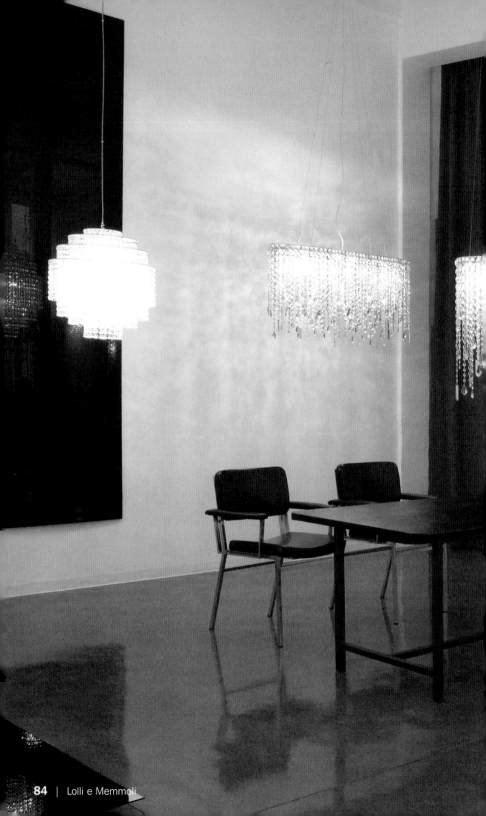

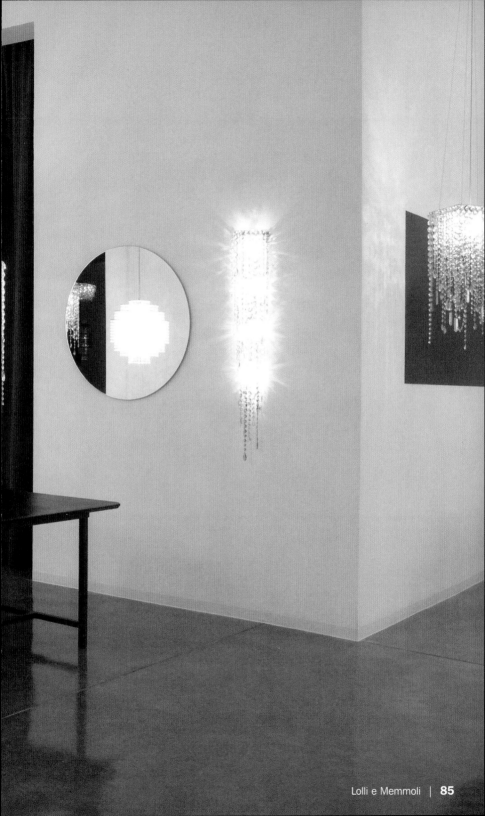

Lollipops

Design: Marjorie Mathieu

Via San Pietro all'Orto 9 | 20121 Milan | Quadrilatero
www.lollipops.fr
Phone: +39 02 36536789
Opening year: 2004
Opening hours: Tue–Sat 10 am to 7 pm
Subway: San Babila
Products: Fashion bags, shoes and accessories
Special features: Colorful and trendy bags

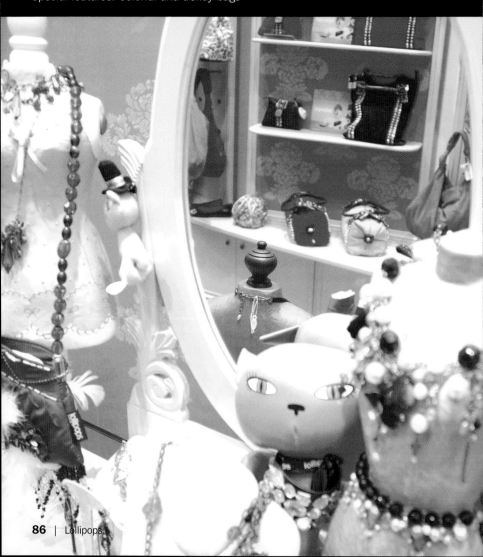

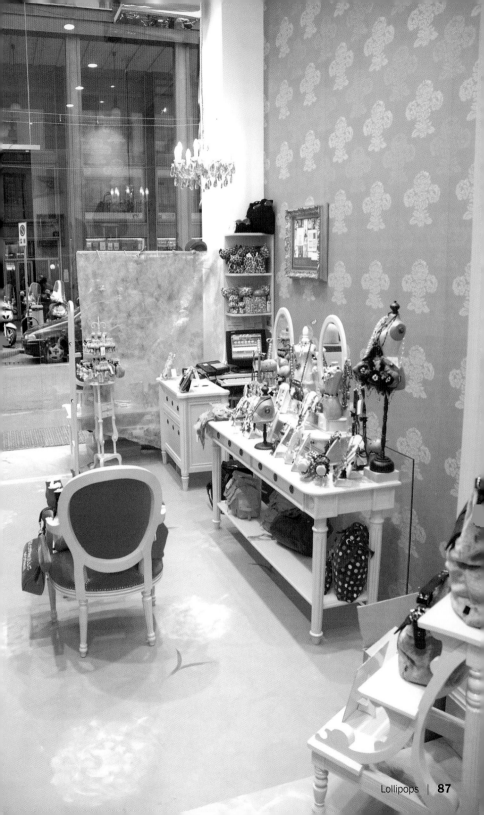

Marni

Design: Future Systems

Via Sant' Andrea 14 | 20121 Milan | Quadrilatero
Phone: +39 02 76317327
Opening year: 2000
Opening hours: Mon–Sat 10 am to 7pm
Subway: San Babila, Montenapoleone
Products: Fashion

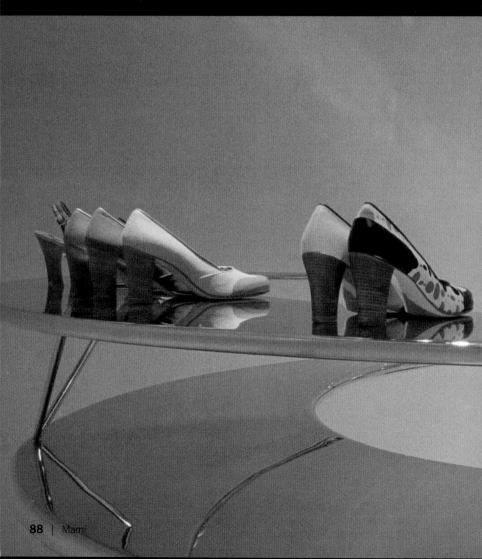

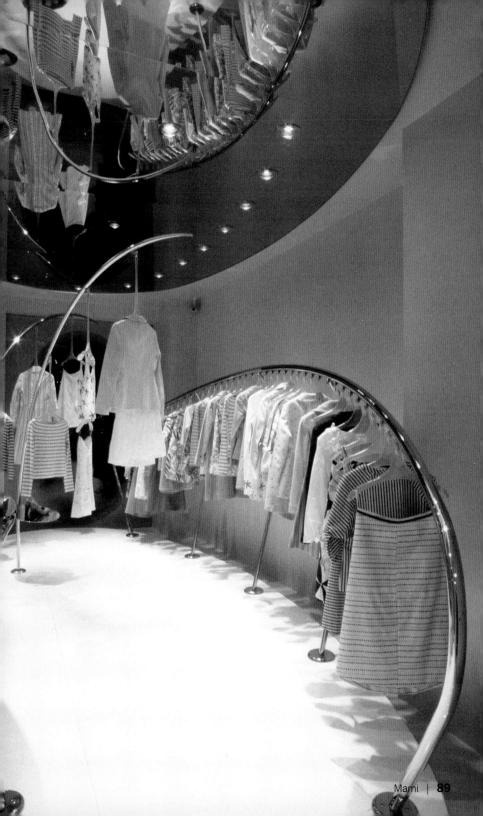

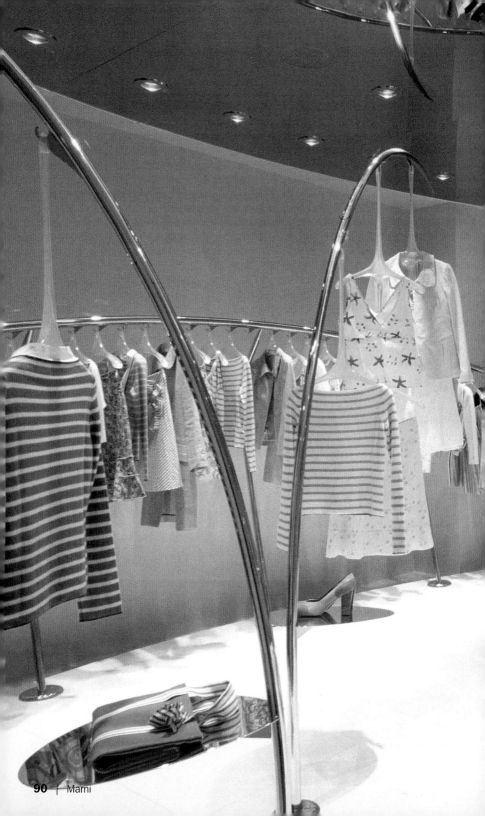

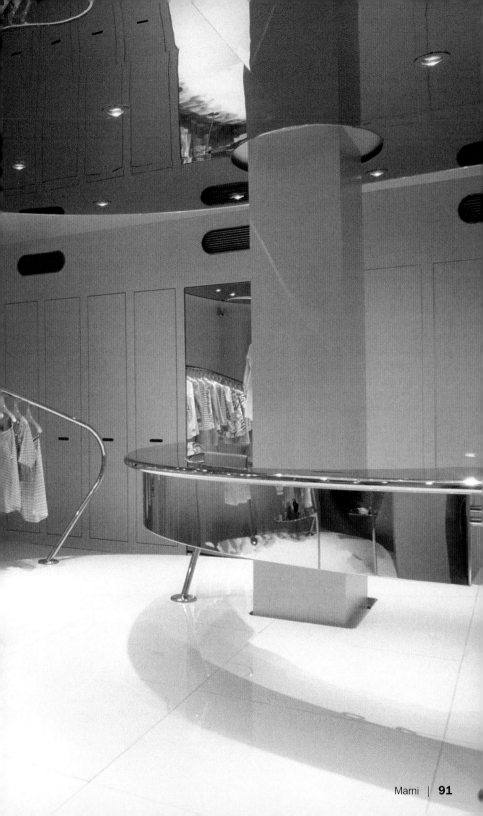

Miu Miu

Design: Roberto Baciocchi

Corso Venezia 3 | 20121 Milan | San Babila
www.miumiu.com
Phone: +39 02 76001799
Opening year: 2001
Opening hours: Mon–Sat 10 am to 7:30 pm
Products: Fashion

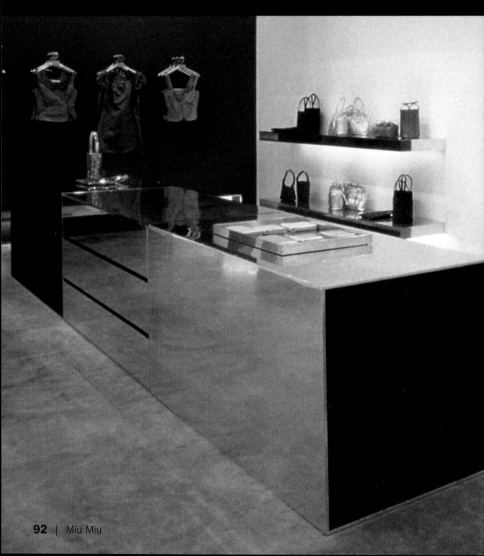

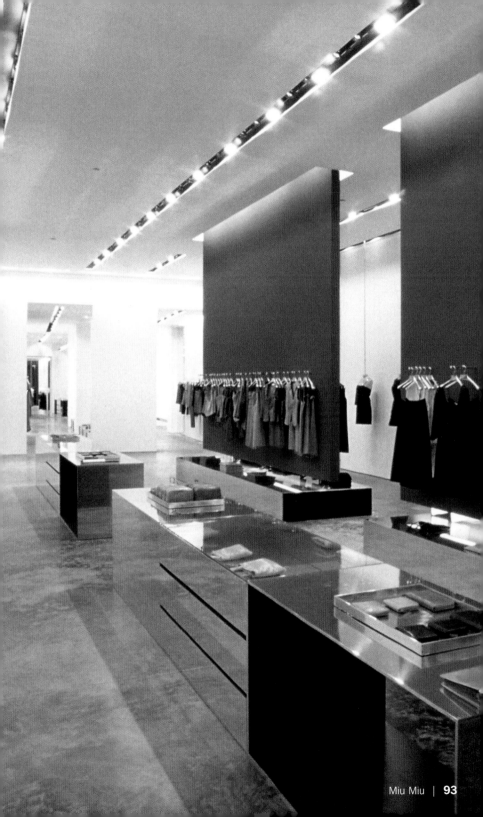

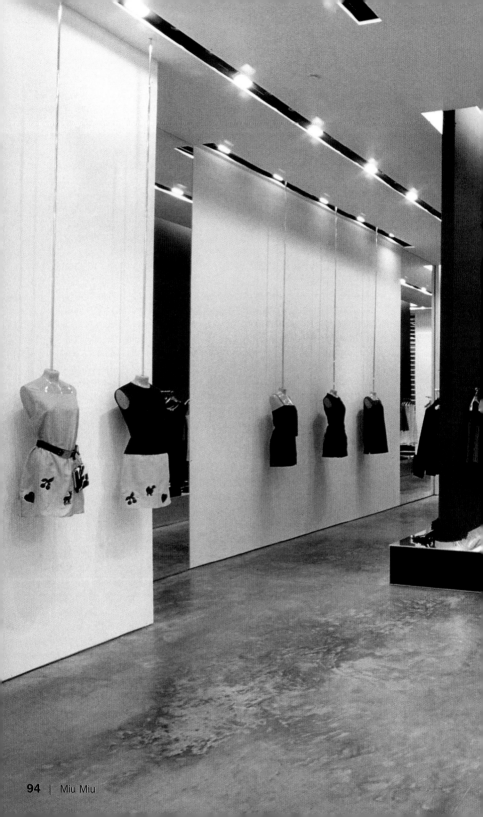

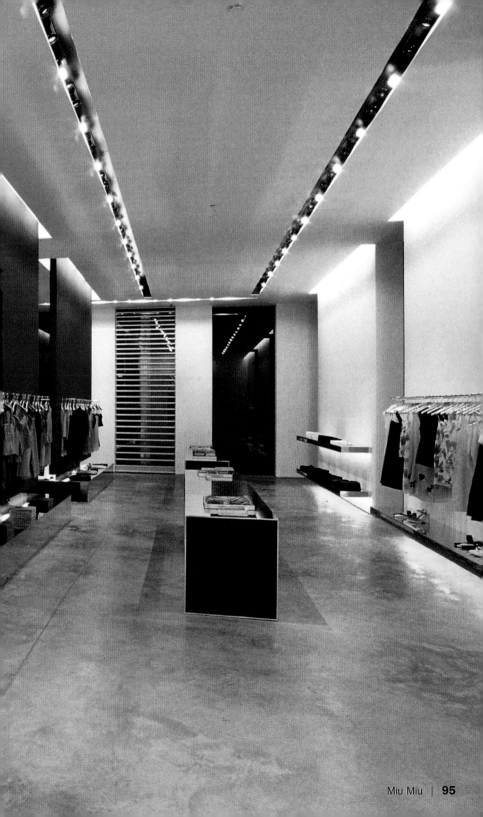

Moschino

Design: Sean Dix

Via Sant' Andrea 12 | 20121 Milan | Quadrilatero
www.moschino.it
Phone: +39 02 76000832
Opening year: 2000
Opening hours: Every day 10:30 am to 1 pm and 3:30 pm to 7:30 pm
Subway: San Babila
Products: Clothes, shoes, accessories

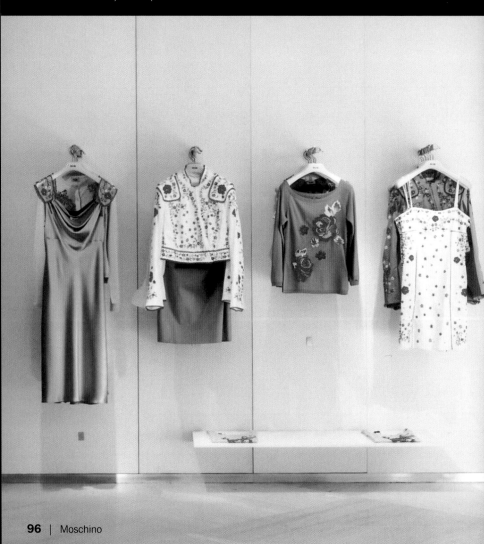

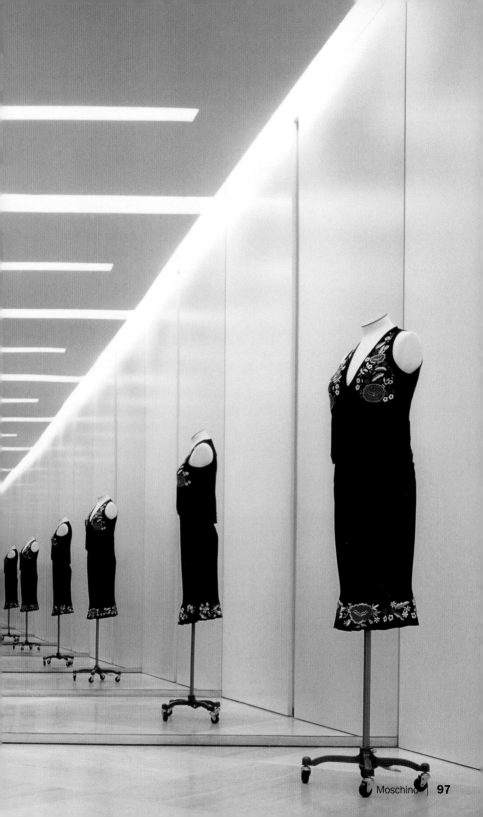

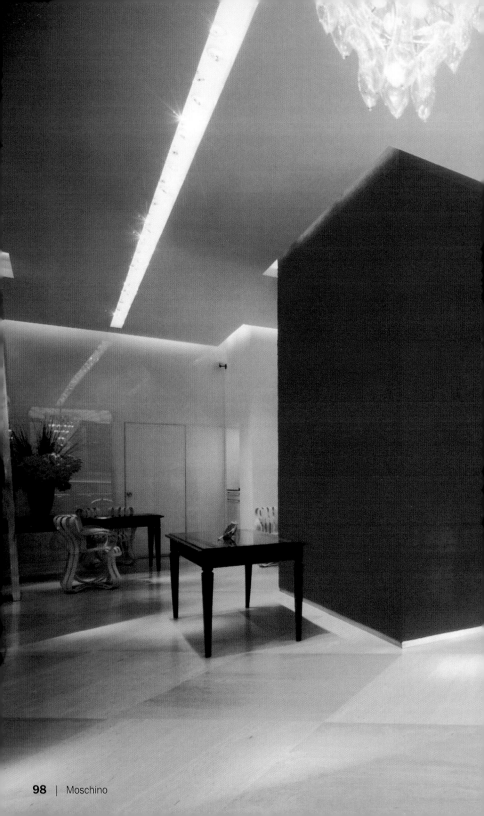

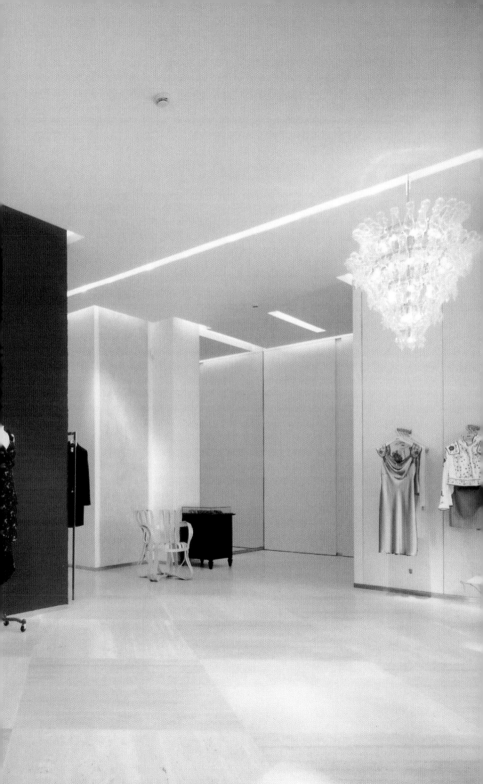

Moschino Cheap&Chic

Design: Sean Dix

Via della Spiga 30 | 20121 Milan | Quadrilatero
www.moschino.it
Phone: +39 02 76007605
Opening year: 2002
Opening hours: Tue–Sat 10 am to 7 pm, Mon 3 pm to 7 pm
Subway: San Babila
Products: Clothes, shoes, accessories
Special features: Decorative lace lamps

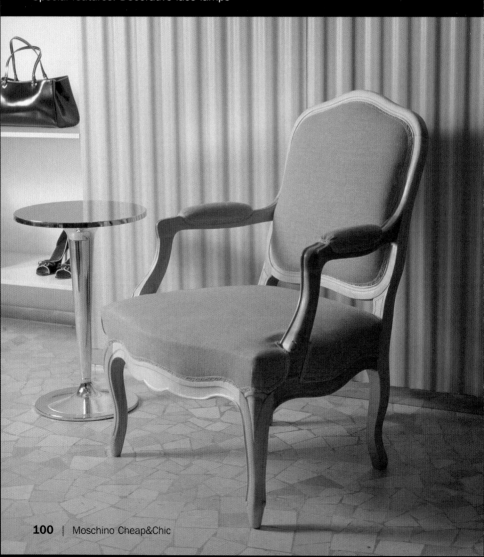

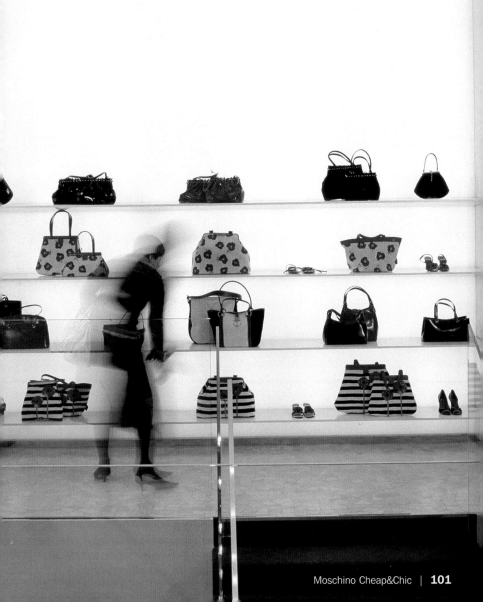

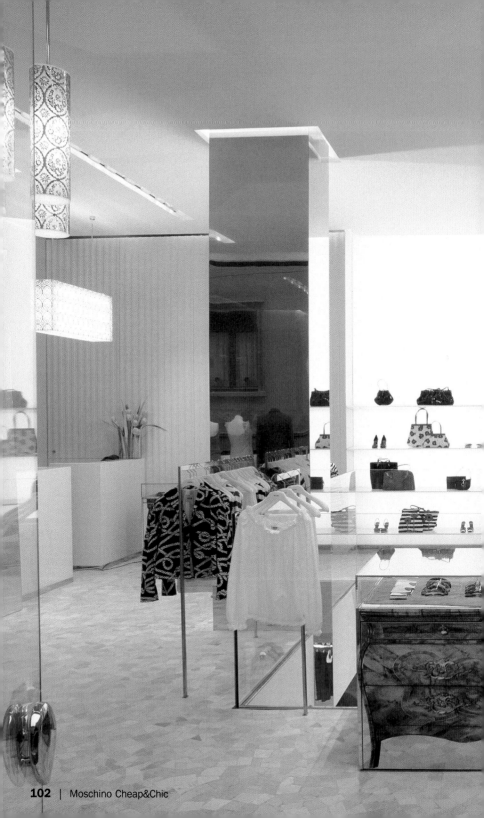

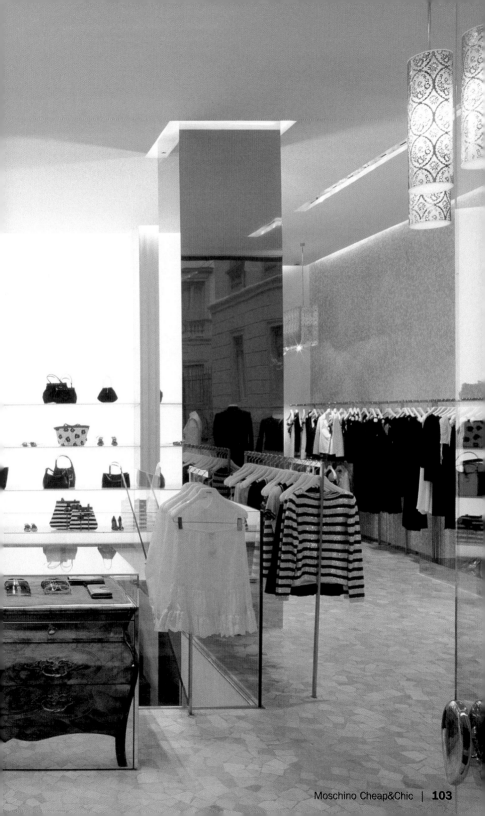

Paul Smith

Design: Sophie Hicks

Via Manzoni 30 | 20121 Milan | Quadrilatero
www.paulsmith.co.uk
Phone: +39 02 76319181
Opening year: 2001
Opening hours: Mon–Sat 10 am to 7 pm
Subway: Montenapoleone
Products: Fashion

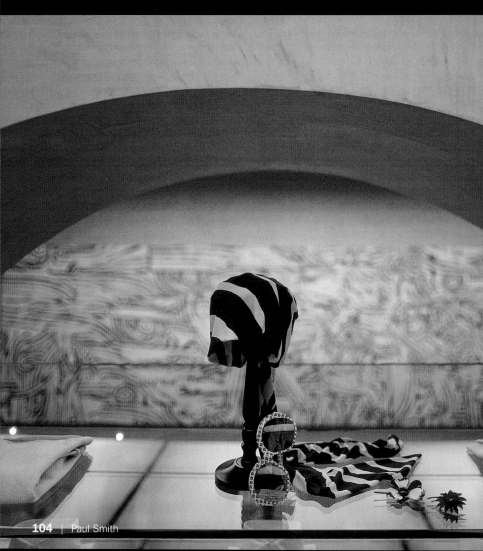

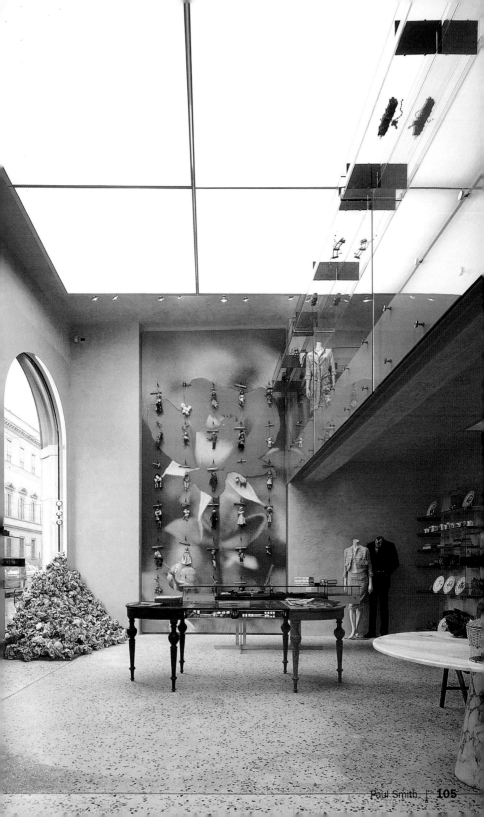

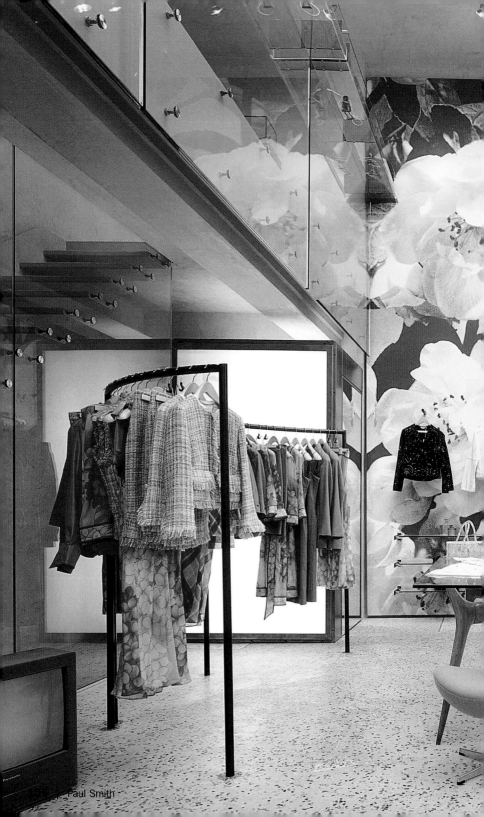

Paul Smith

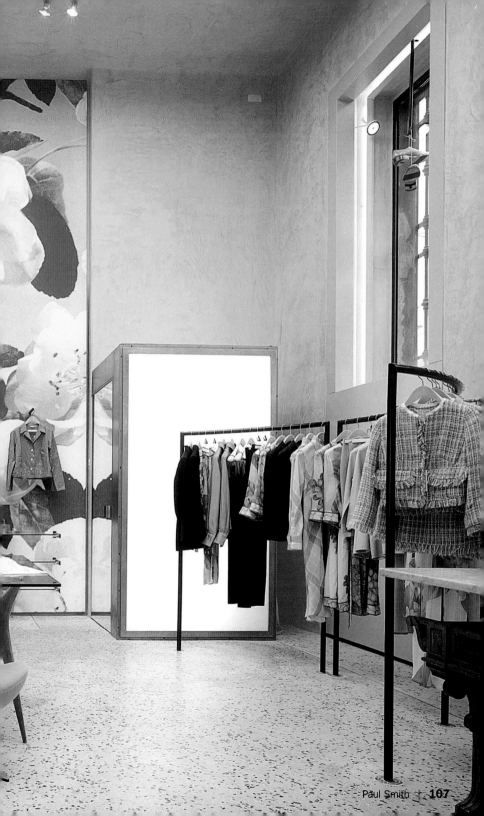

Pianegonda

Via Montenapoleone 6 | 20121 Milan | Quadrilatero
www.pianegonda.com
Phone: +39 02 76003038
Opening hours: Mon–Sat 10 am to 7pm
Subway: San Babila
Products: Jewelry

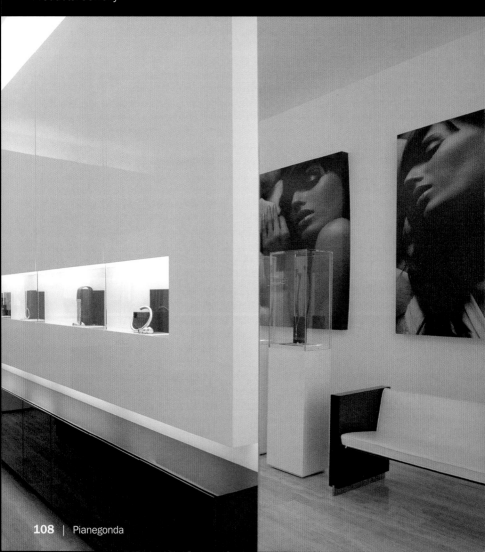

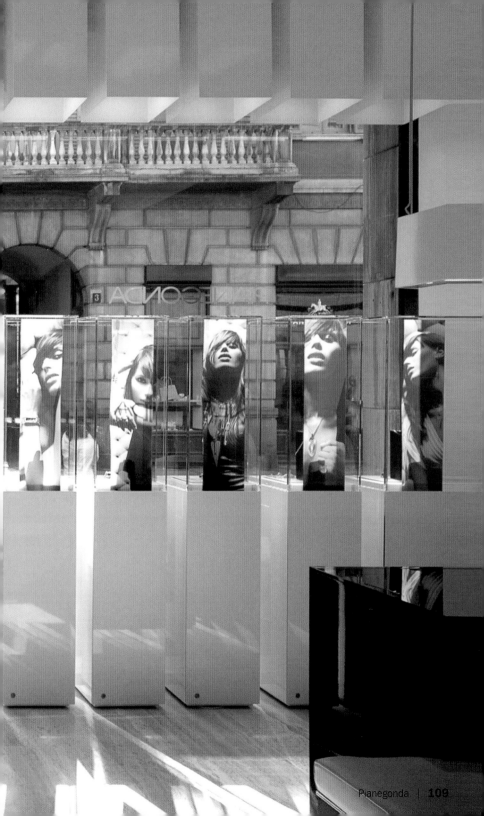

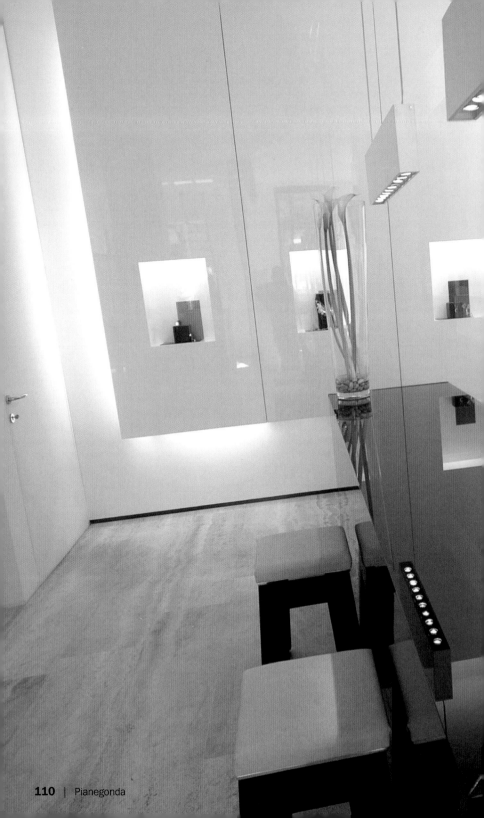

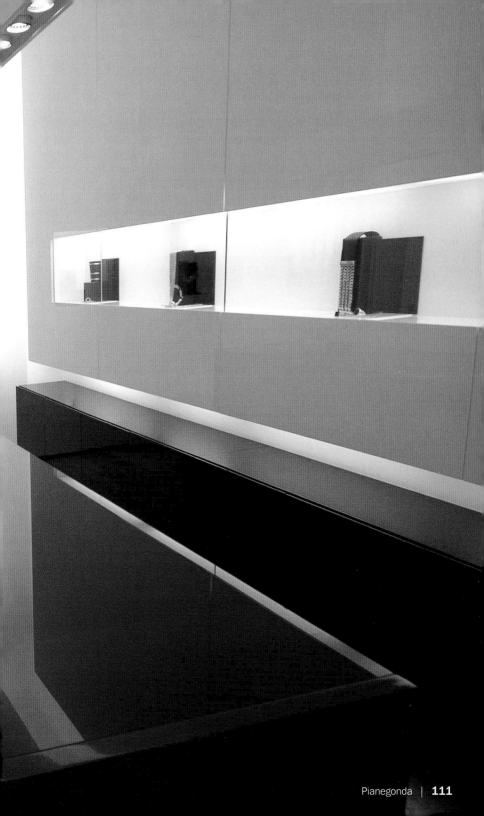

Via Montenapoleone 8 | 20121 Milan | Quadrilatero
www.prada.com
Phone: +39 02 7771771
Opening year: 2001
Opening hours: Mon–Sat 10 am to 7:30 pm, Sun 10 am to 7:30 pm
Subway: Centrale
Products: Fashion

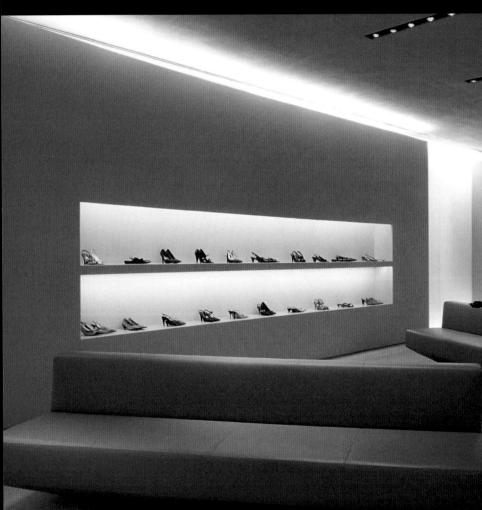

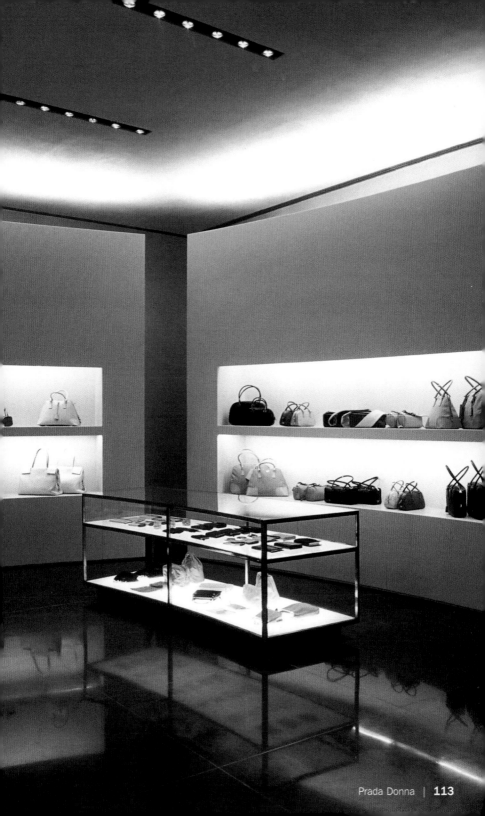

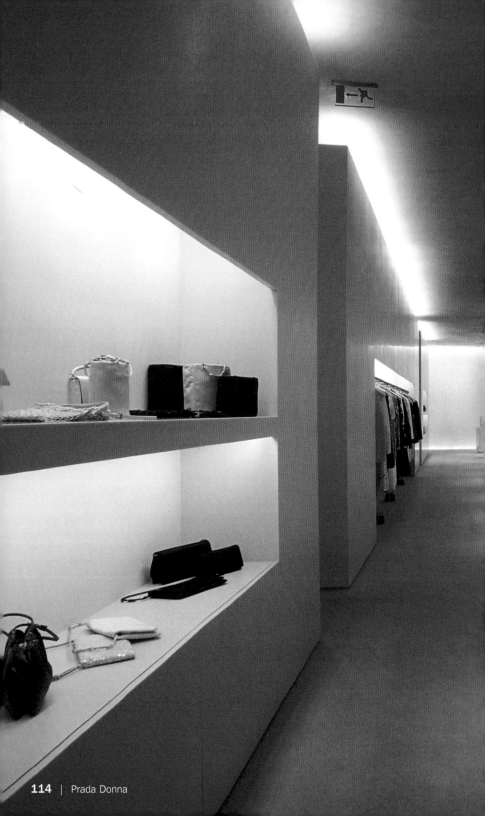

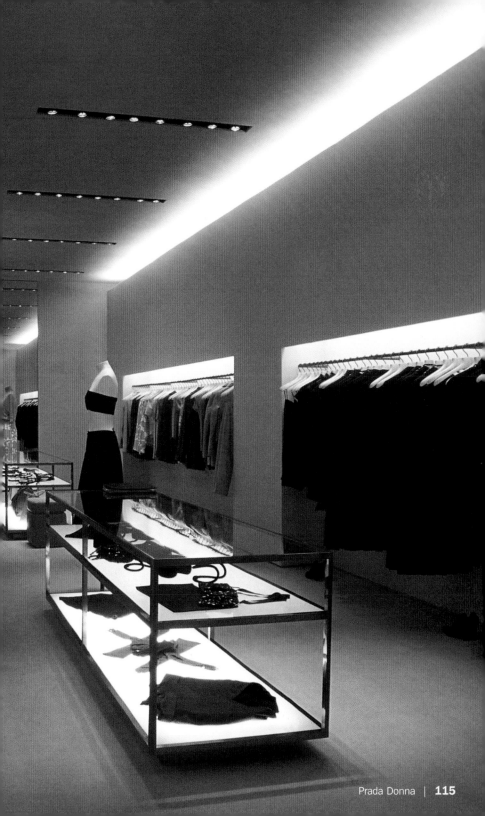

Princi Bakery

Design: Claudio Silvestrin Architects, Giuliana Salmaso

Piazza XXV Aprile 5 | 20121 Milan | Quadrilatero
Phone: +39 02 29060832
Opening year: 2004
Opening hours: 24 hours every day
Subway: Moscova
Products: Food, bread

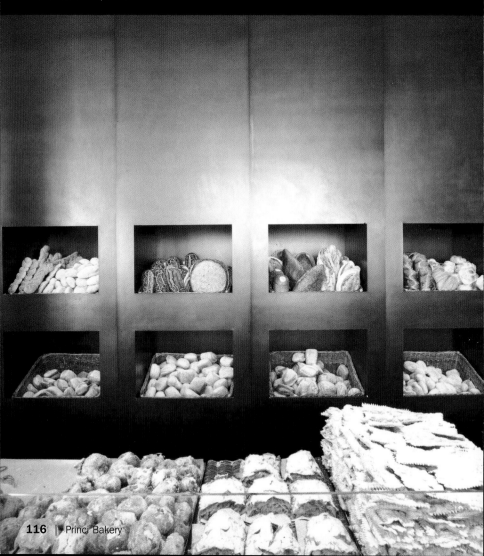

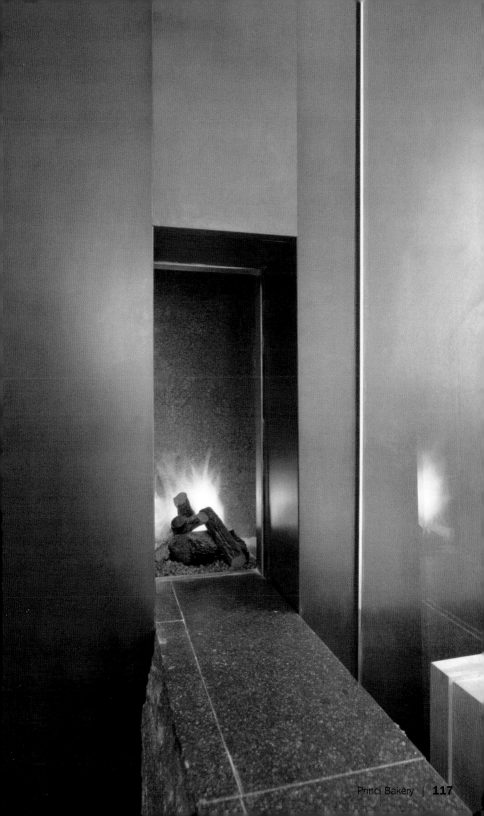

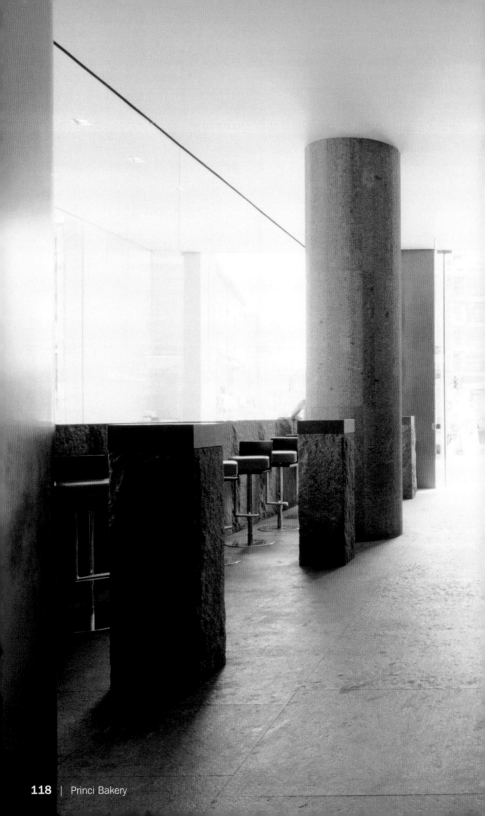

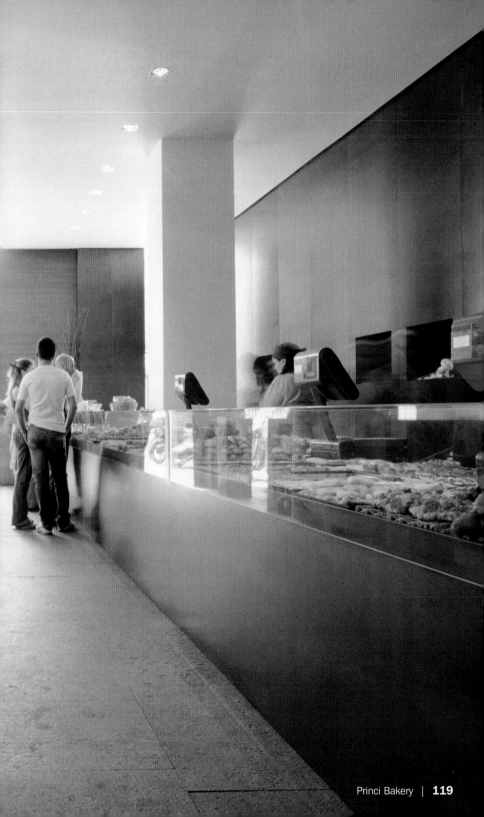

Roberta Balsamo

Design: Roberta Balsamo

Via Cerva 6 | 20122 Milan | San Babila
Phone: +39 02 76398336
Opening year: 2004
Opening hours: Mon–Fri 11 am to 7 pm
Subway: San Babila
Products: Bags, mirrors and objects, accessories

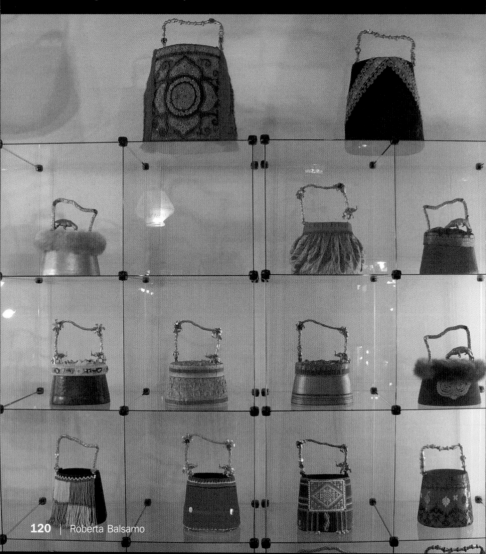

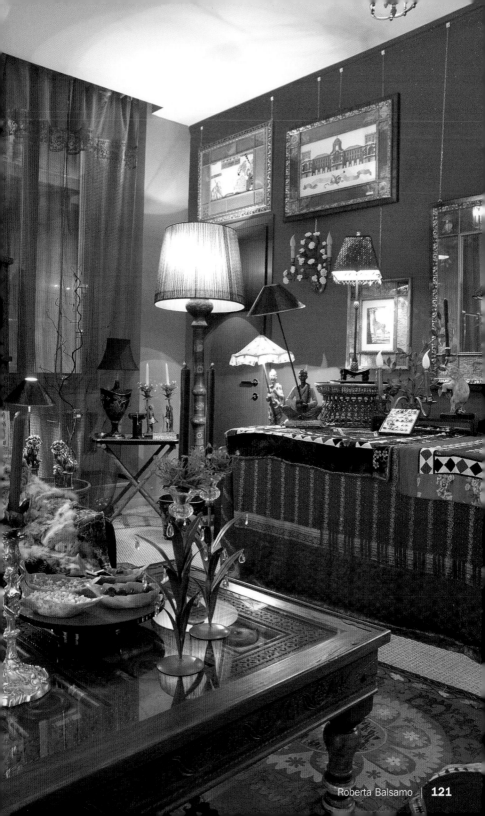

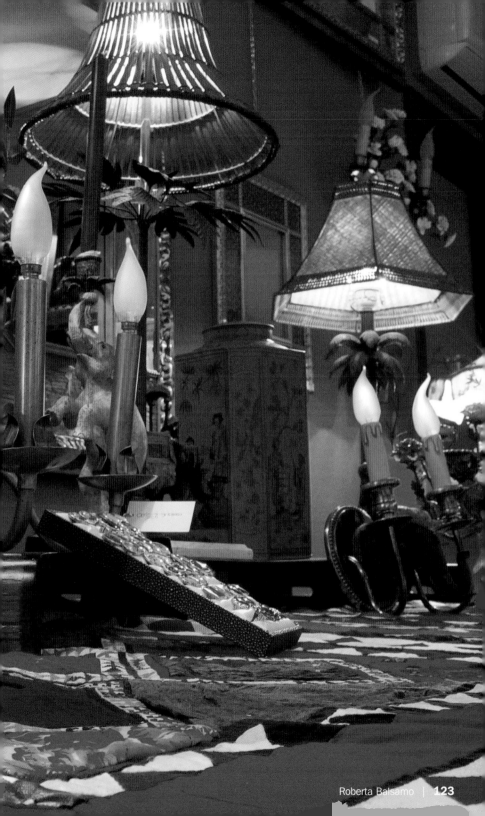

Spazio 900

Viale Campania 51 | 20133 Milan | Lambrate
www.spazio900.com
Phone: +39 02 70125737
Opening year: 1998
Opening hours: Mon–Sat 3:30 pm to 7:30 pm
Subway: Stazione Porta Vittoria, Piazza Piola
Products: Modernism, design 50s–80s and vintage furnitures
Special features: Events, exhibition, hire

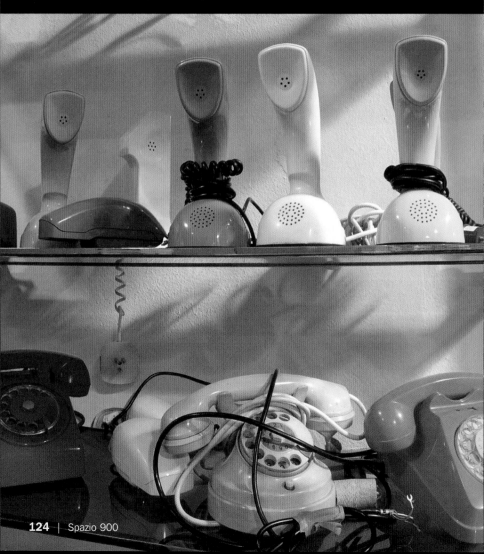

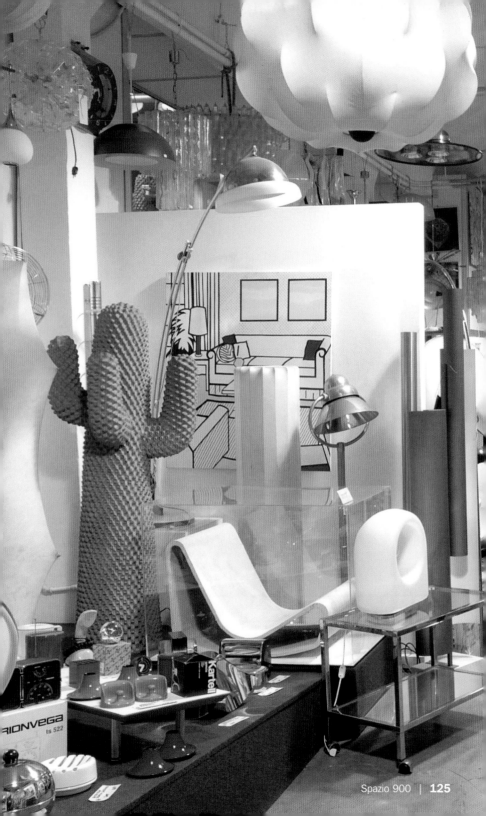

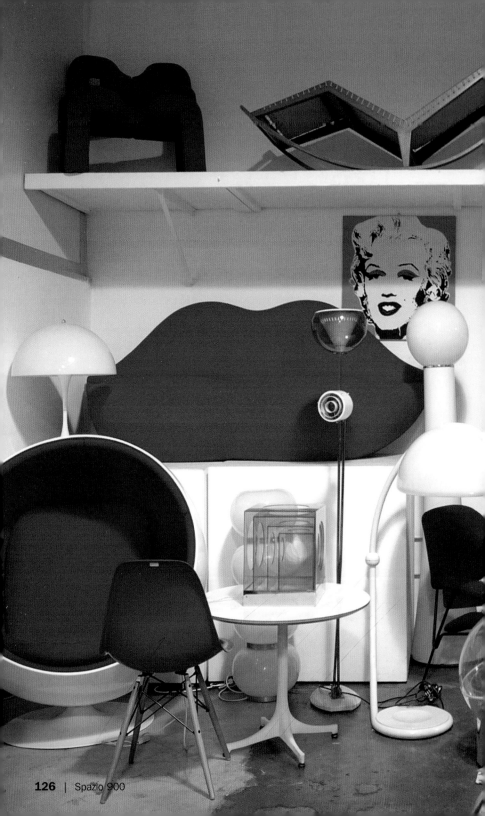

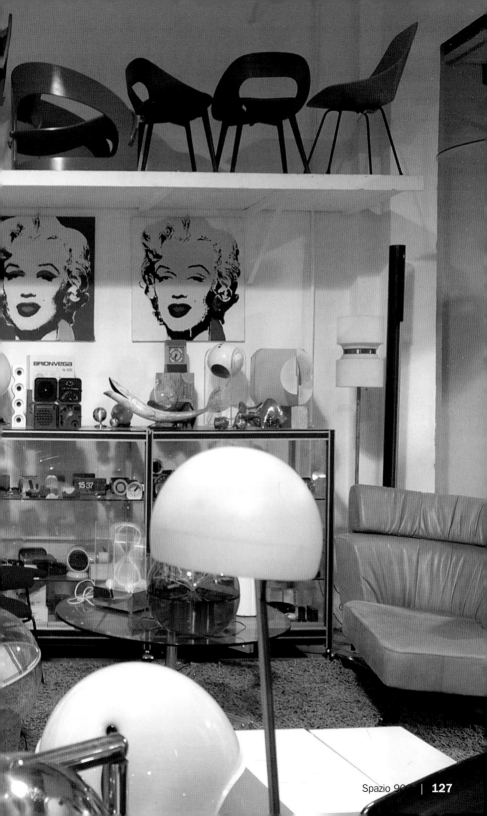

Spazio Armani

Design: Gabellini Associates

Via Manzoni 31 | 20121 Milan | Quadrilatero
www.armani-viamanzoni31.it
Phone: +39 02 72318600
Opening year: 2000
Opening hours: Mon–Sun 10:30 am to 7:30 pm
Subway: Montenapoleone
Products: Furniture, shoes, jewelry, lighting, books

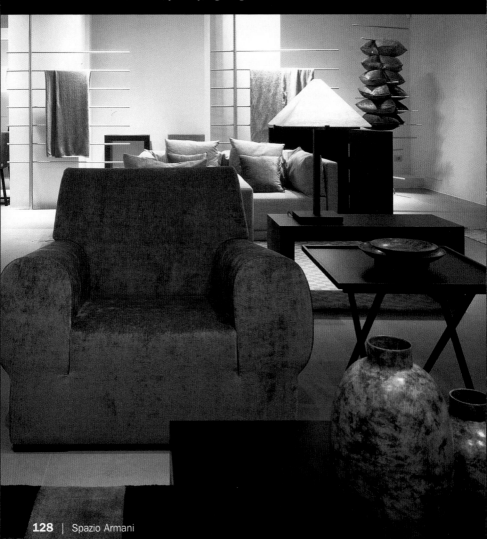

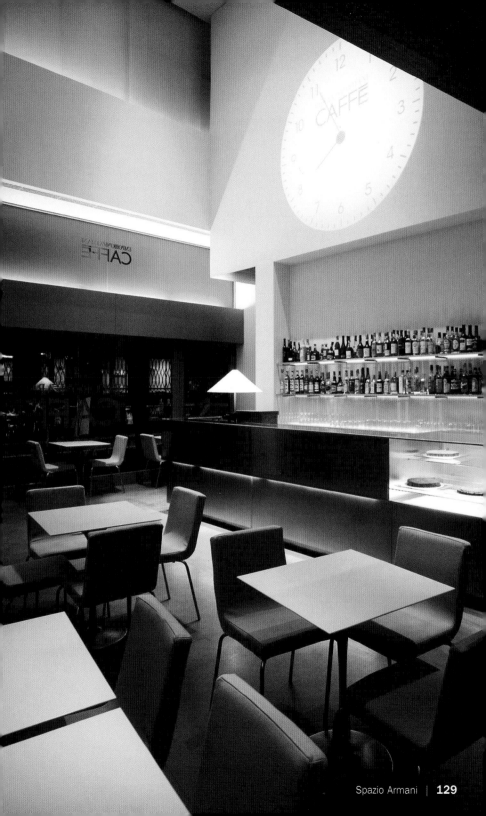

Spazio Bisazza

Design: Fabio Novembre

Via Senato 2 | 20121 Milan | San Babila
www.bisazza.com
Phone: +39 02 76000315
Opening year: 2002
Opening hours: Tue–Sat 10 am to 1:30 pm, 2:30 pm to 7 pm
Subway: San Babila
Products: Glass mosaics
Special features: Events, exhibitions

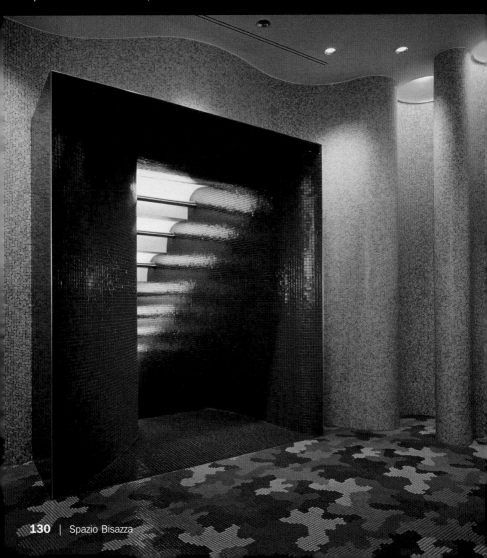

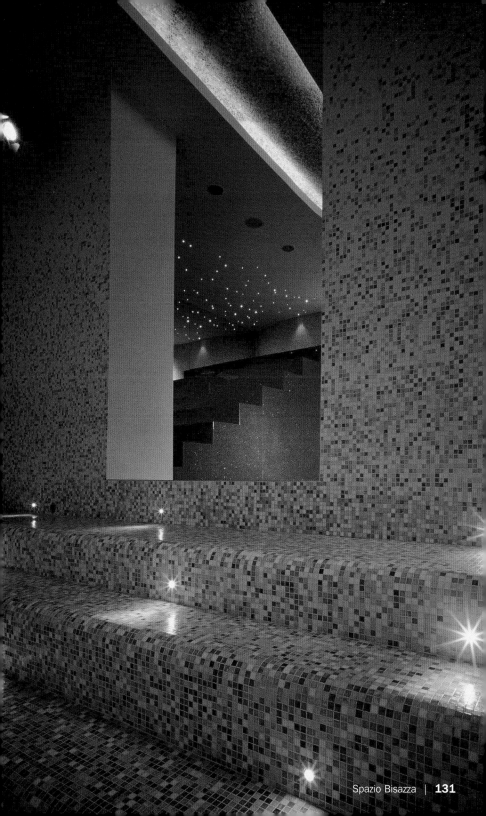

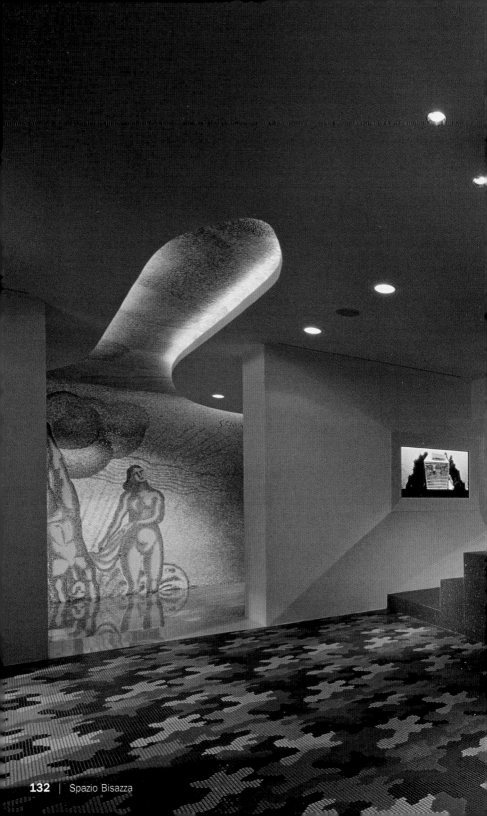

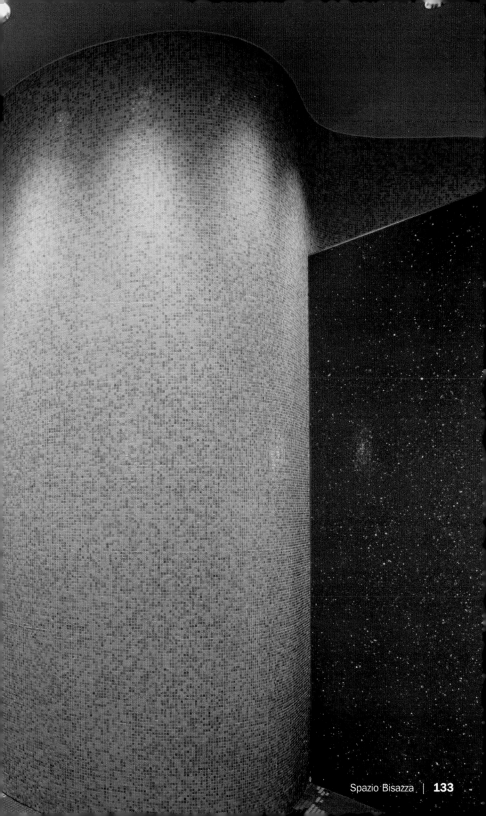

Corso Sempione

ARENA

Parco Sempione

Via M. Pagano

◁─⑲

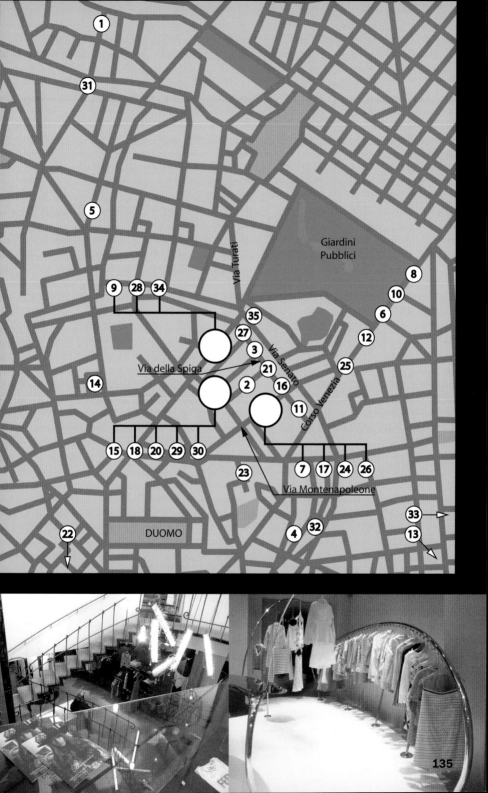

Giardini
Pubblici

Via Turati

Via della Spiga

Via Senato

Corso Venezia

Via Montenapoleone

DUOMO

135

COOL SHOPS

Size: 14 x 21.5 cm / 5 $\frac{1}{2}$ x 8 $\frac{1}{2}$ in.
136 pp
Flexicover
c. 130 color photographs
Text in English, German, French,
Spanish and Italian

Other titles in the same series:

ISBN
3-8327-9073-X

ISBN
3-8327-9070-5

ISBN
3-8327-9038-1

ISBN
3-8327-9071-3

ISBN
3-8327-9072-1

ISBN
3-8327-9021-7

ISBN
3-8327-9037-3

**To be published in the
same series:**

Amsterdam
Dubai
Hamburg
Hongkong
Madrid
Miami

San Francisco
Shanghai
Singapore
Tokyo
Vienna

teNeues